The Script Alphabet

BY ARTHUR BAKER

ART DIRECTION BOOK COMPANY, NEW YORK

Library of Congress Catalog Card Number:
78-56103
ISBN: 0-910158-43-6 (cloth)
 0-910158-47-9 (paper)

Published by
Art Direction Book Company
19 West 44th Street
New York, N.Y. 10036
Printed in the United States of America

The true form of the script letter
is a product of centuries of breeding - as
truly a thoroughbred in the world
of the graphic arts as its distinguished
ancestor, the Roman letter.

Tommy Thompson

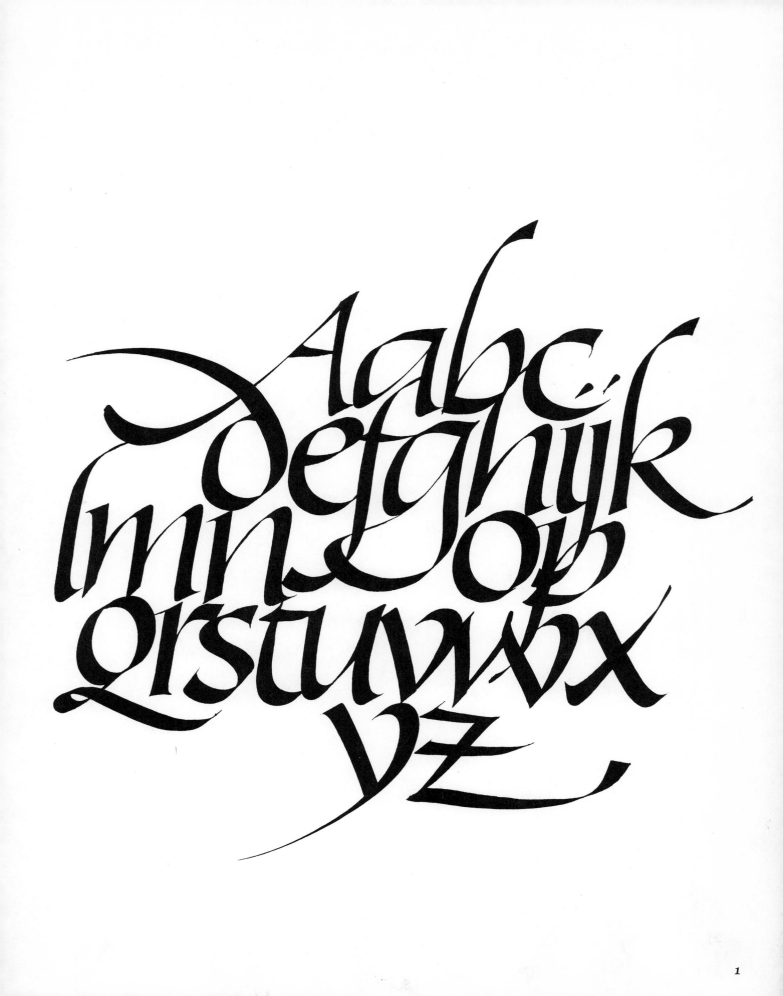

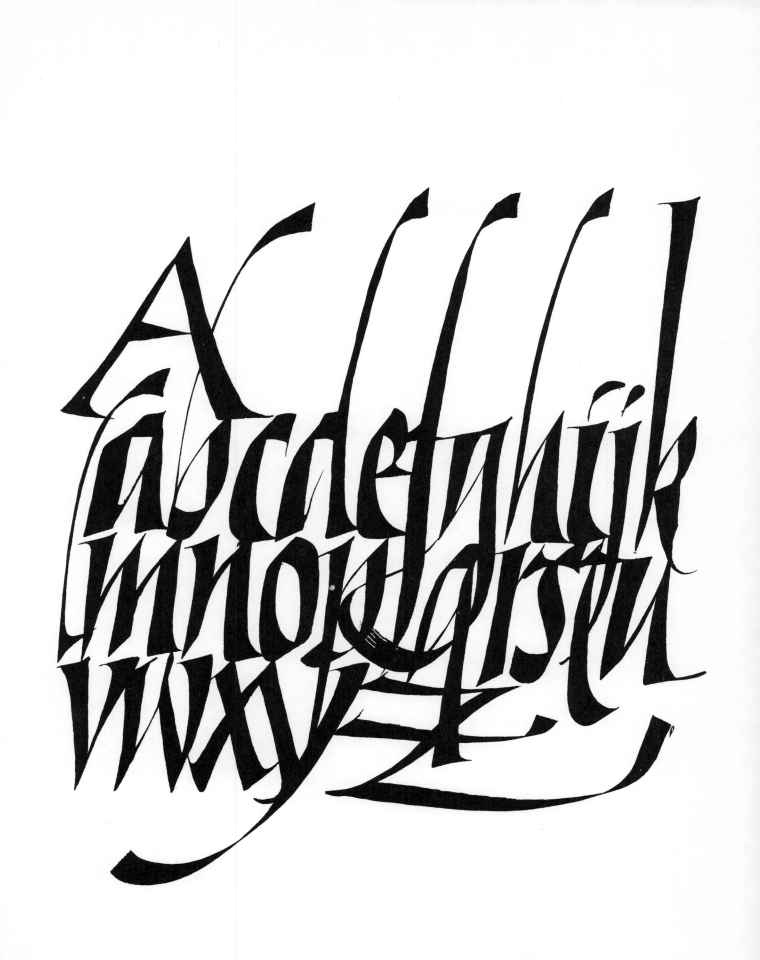

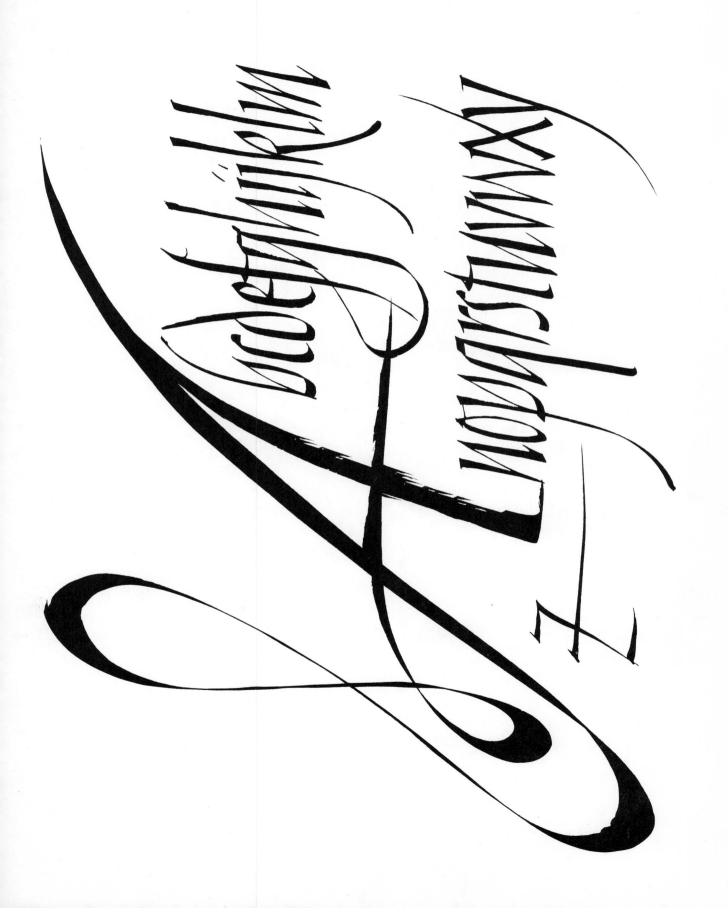

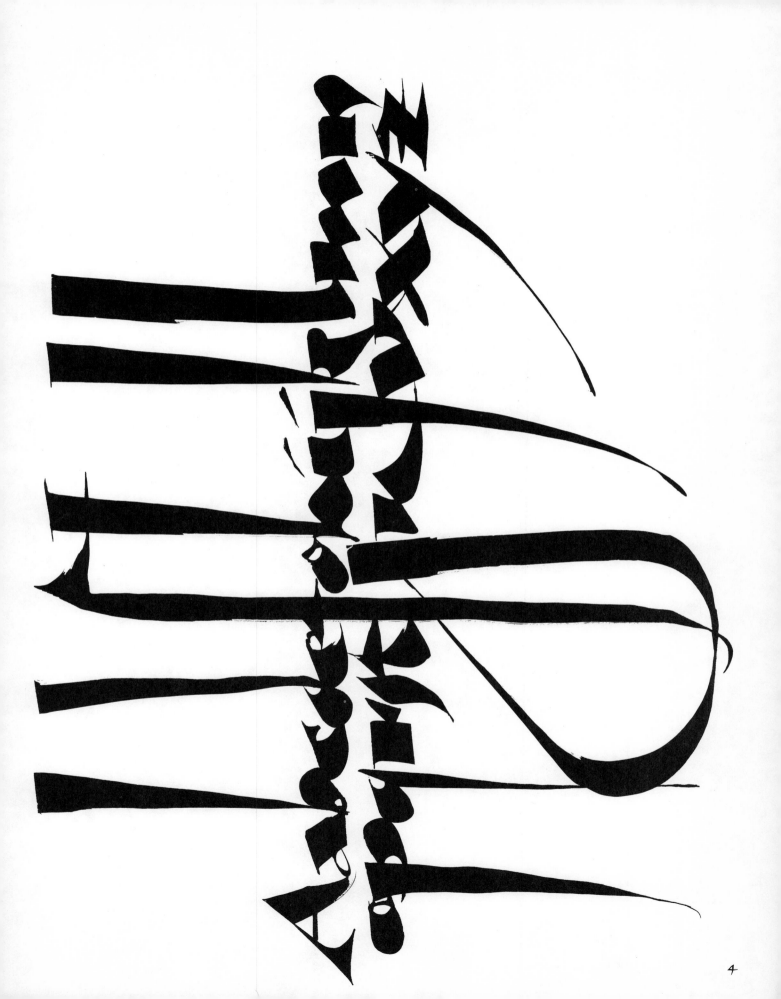

4

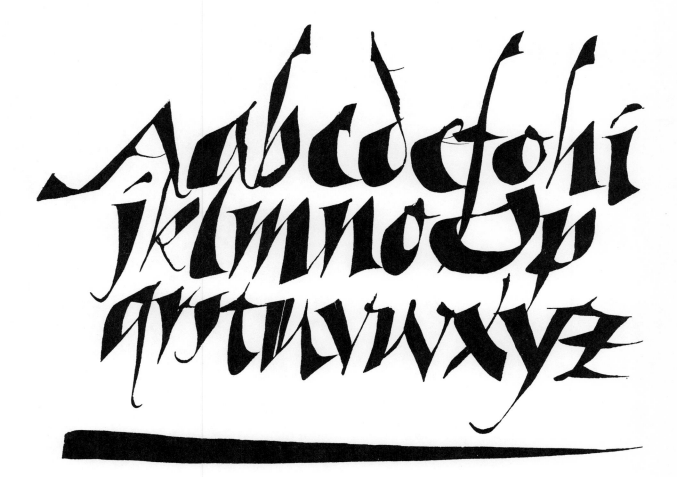

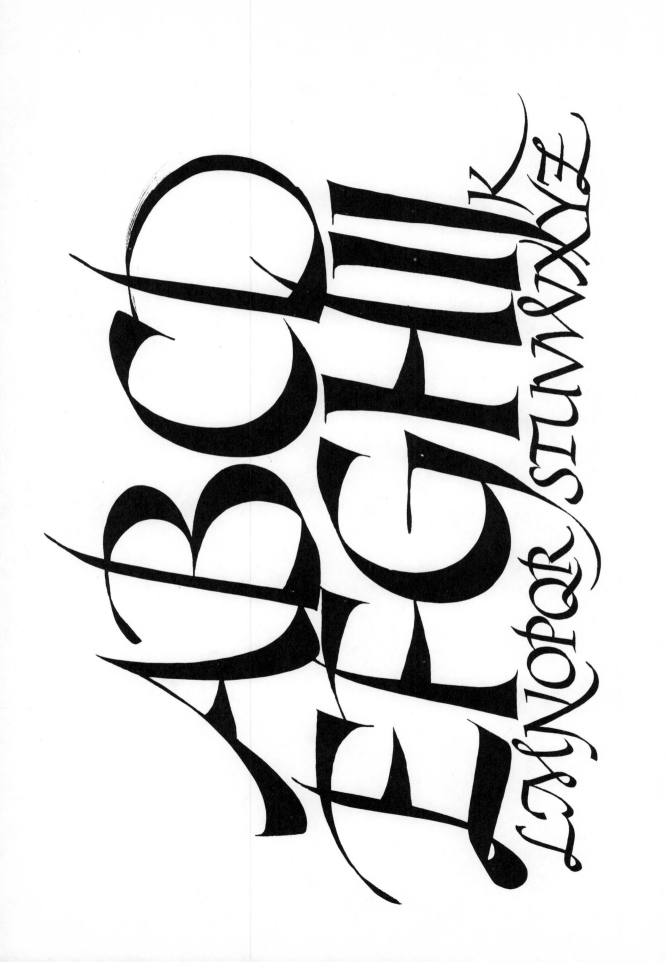

6

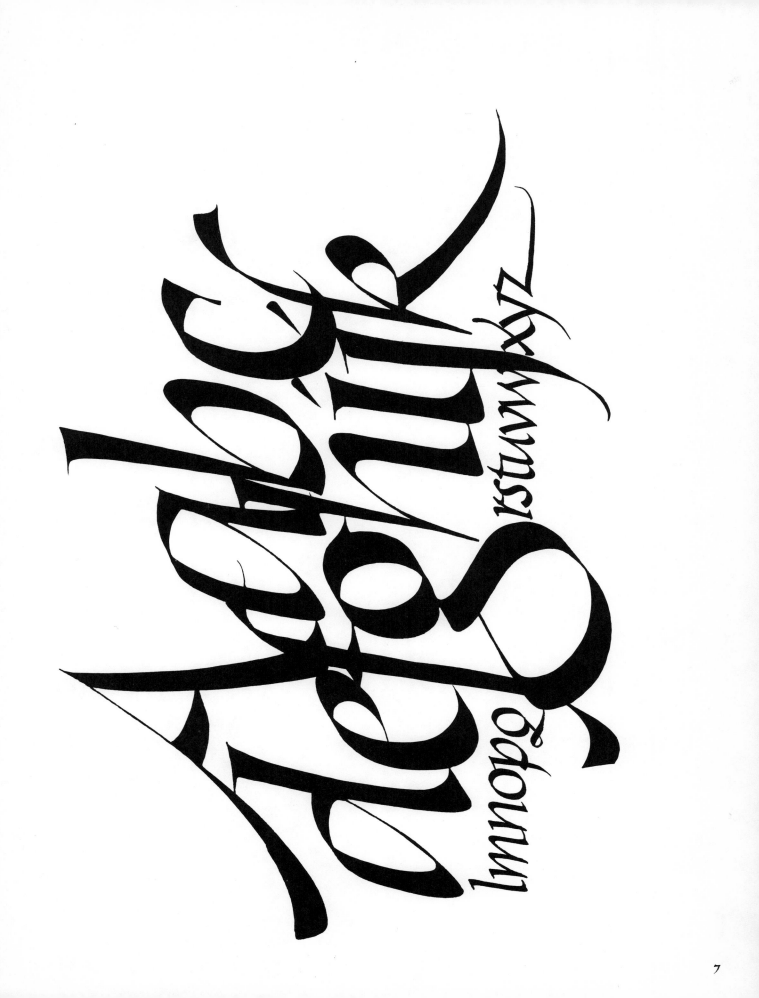

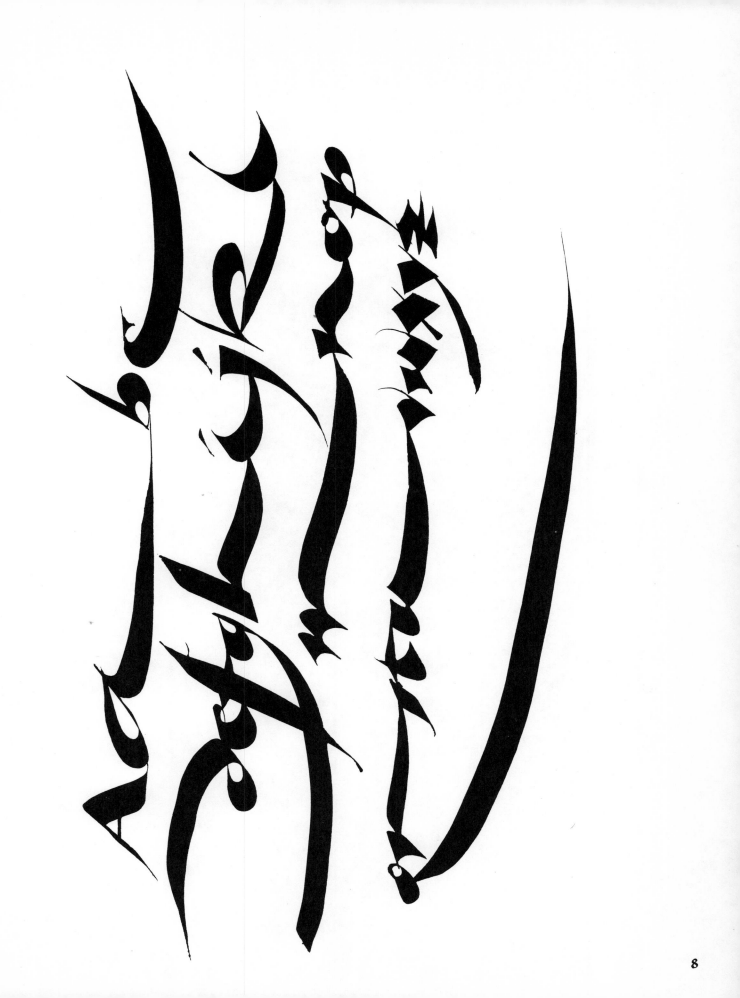

8

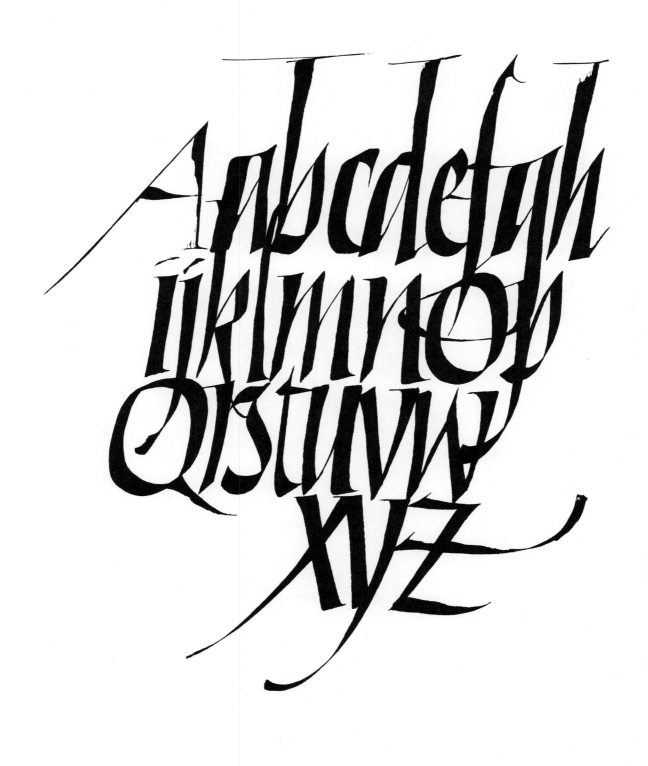

9

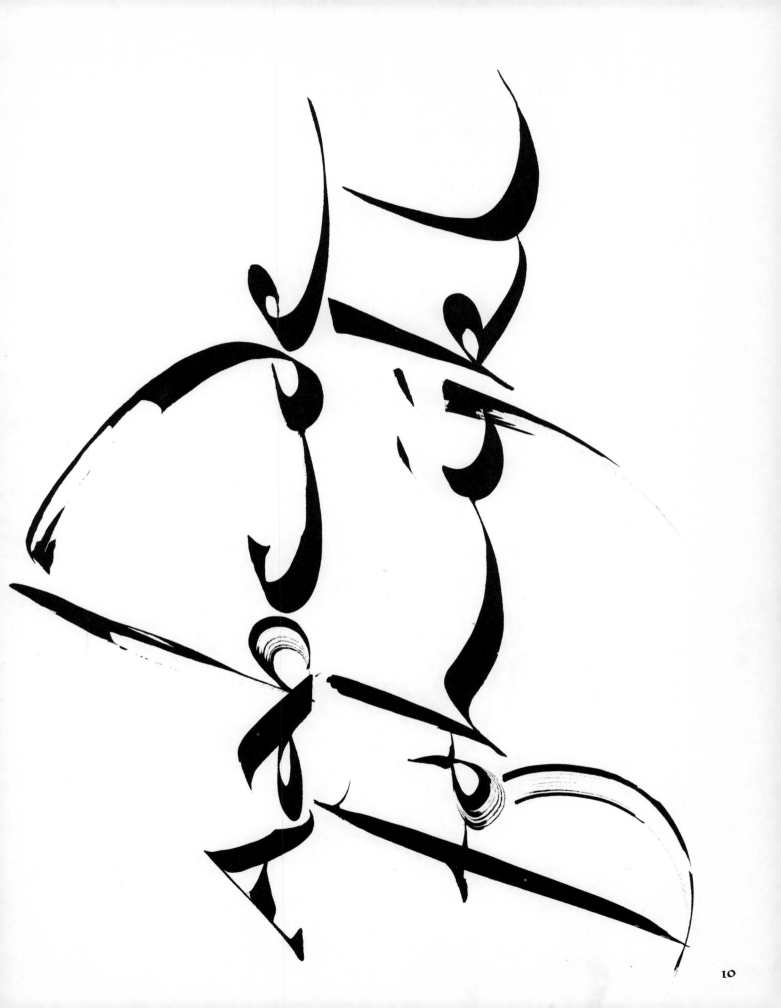

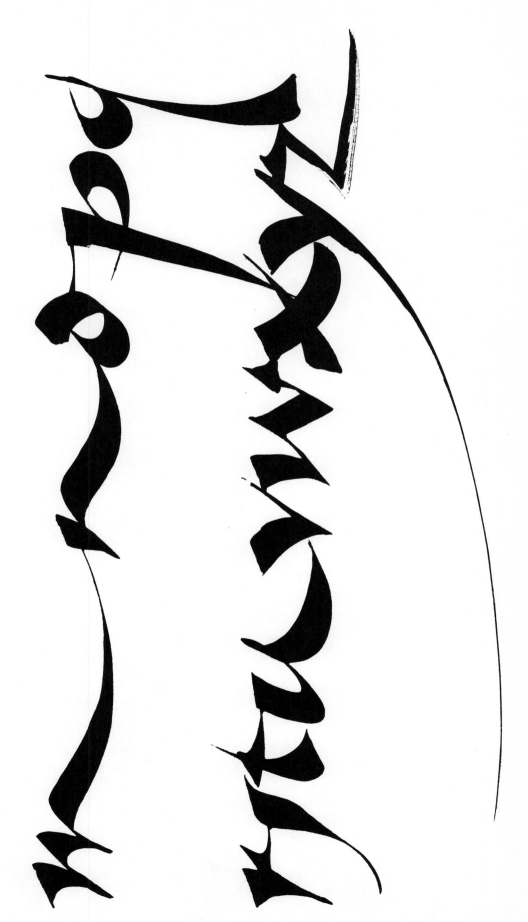

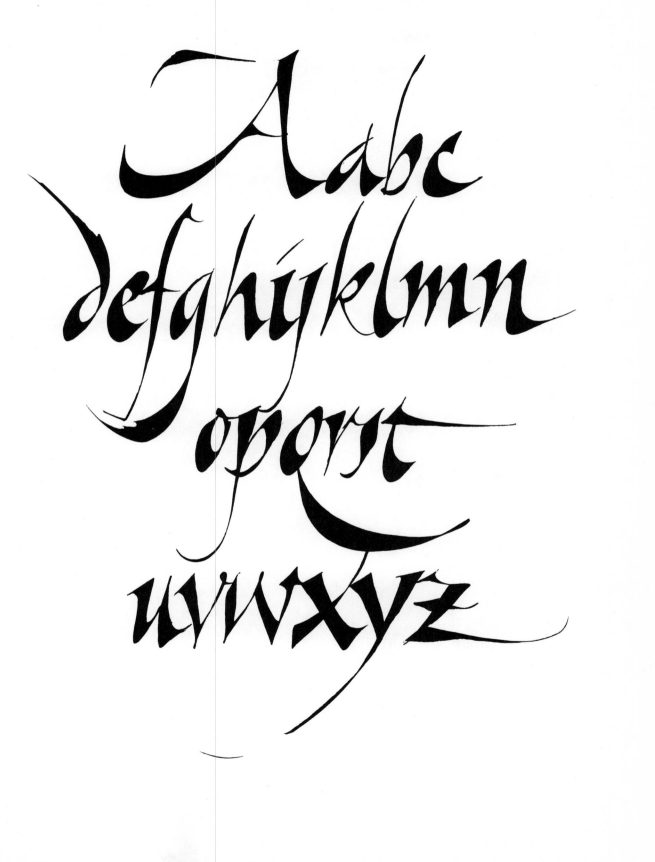

Aabc
defghiyklmn
opqrst
uvwxyz

12

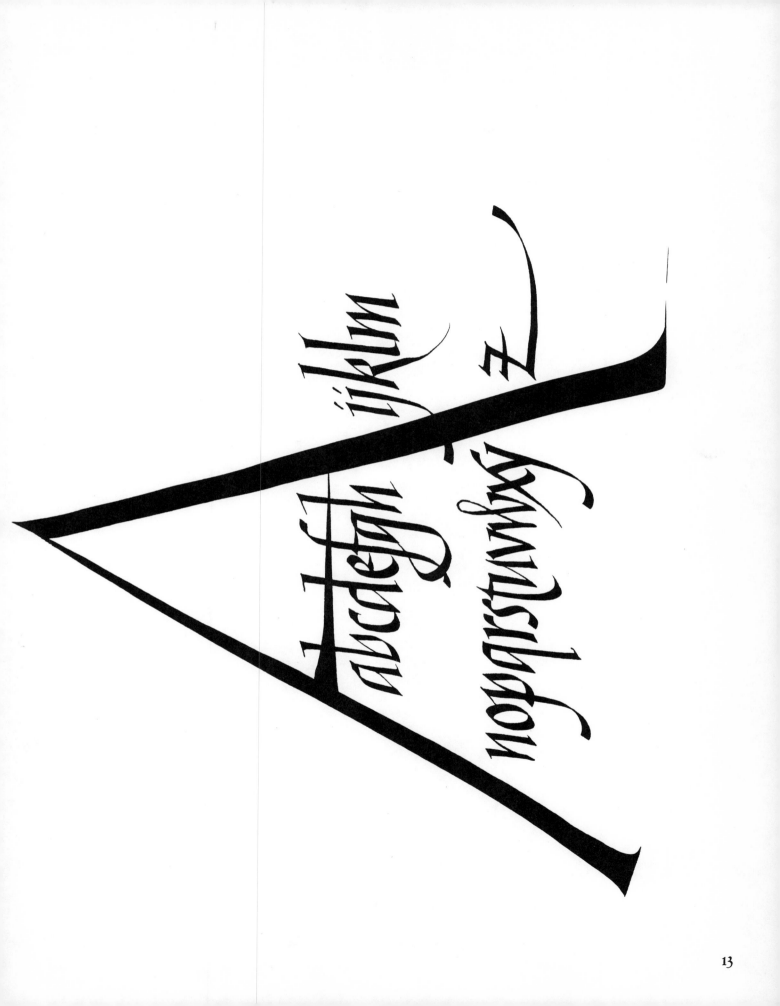

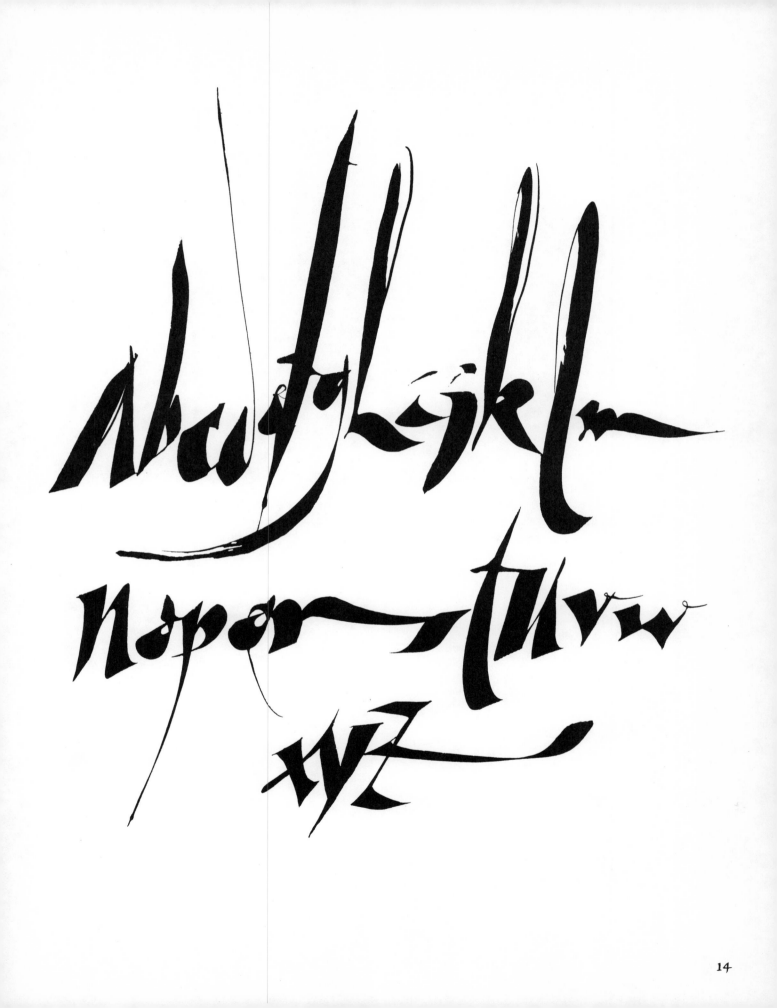

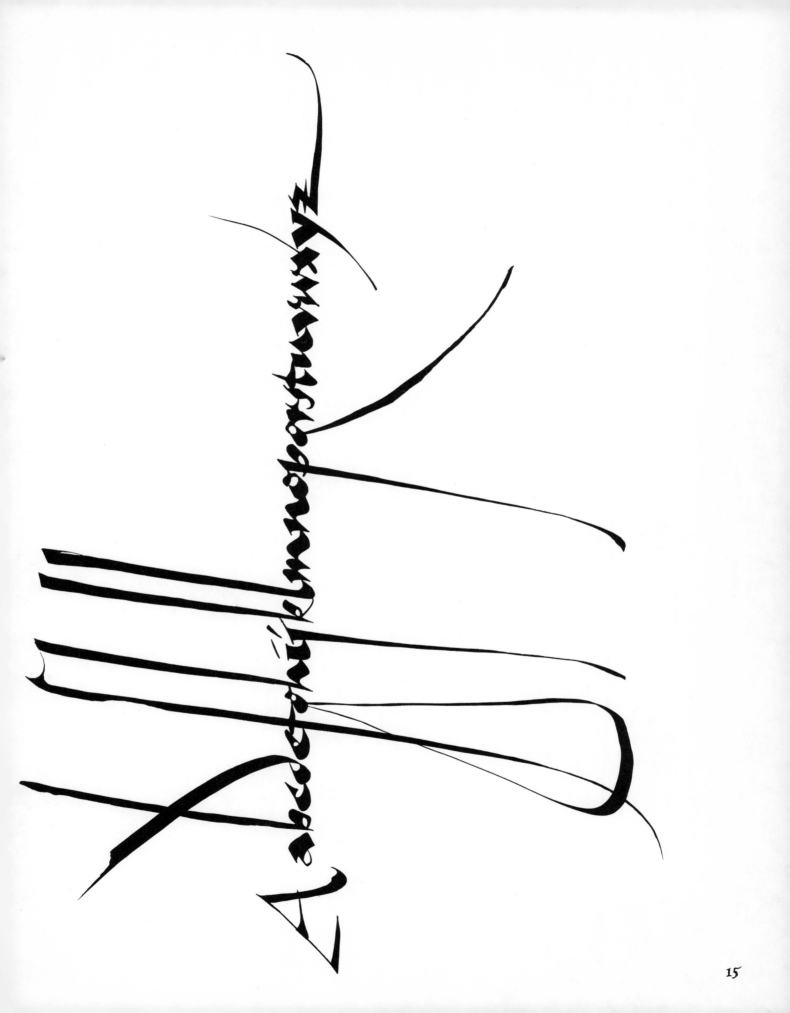

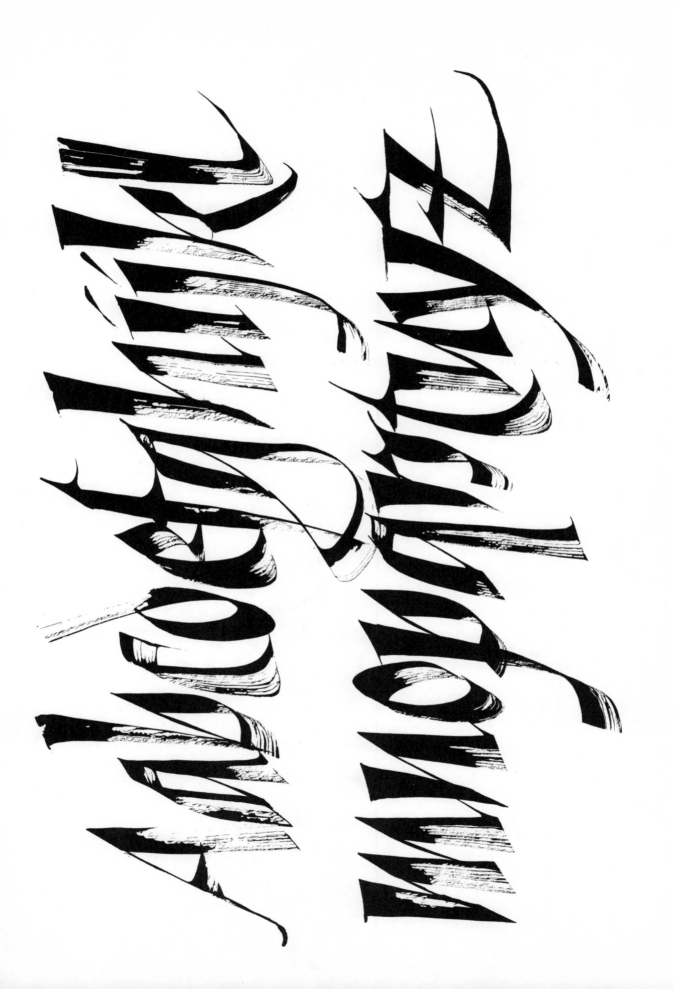

16

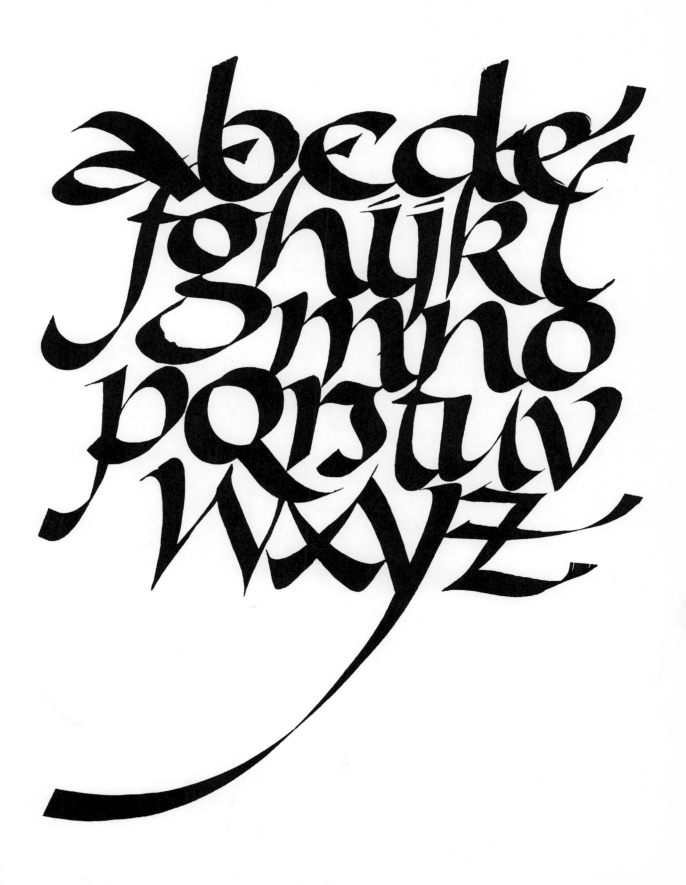

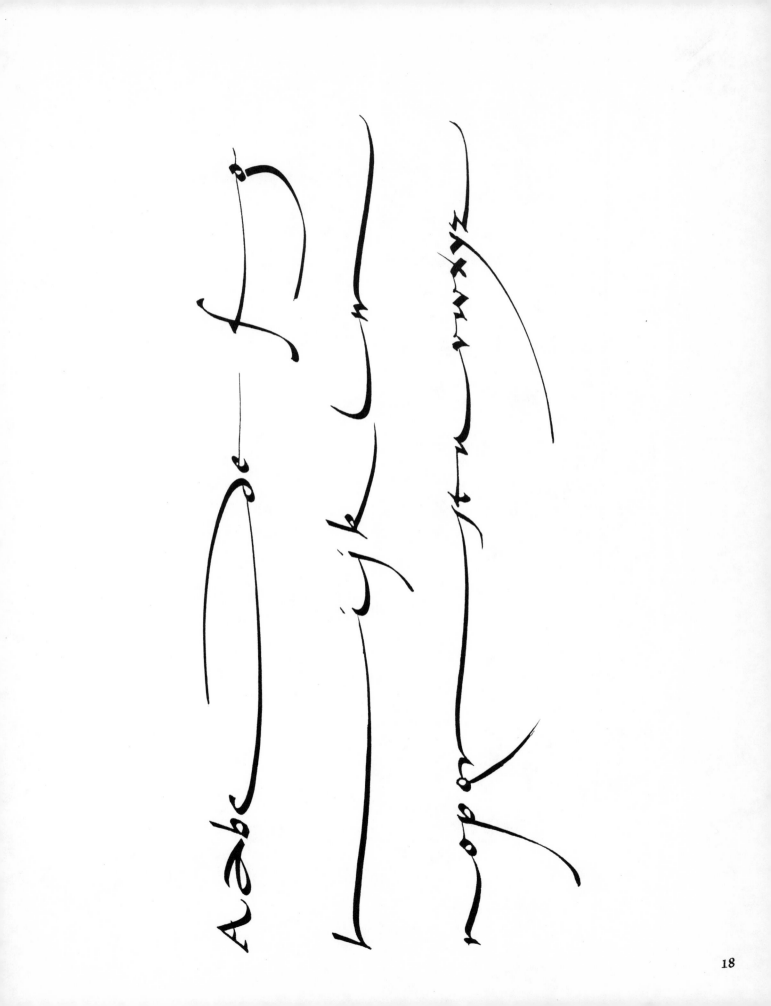

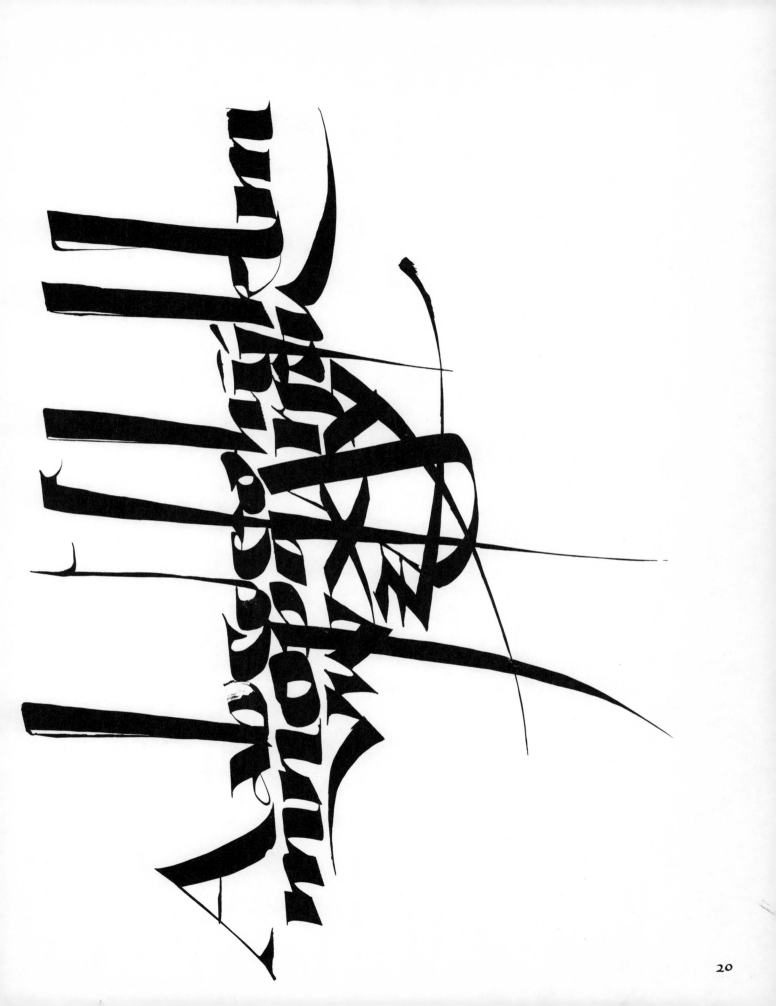

20

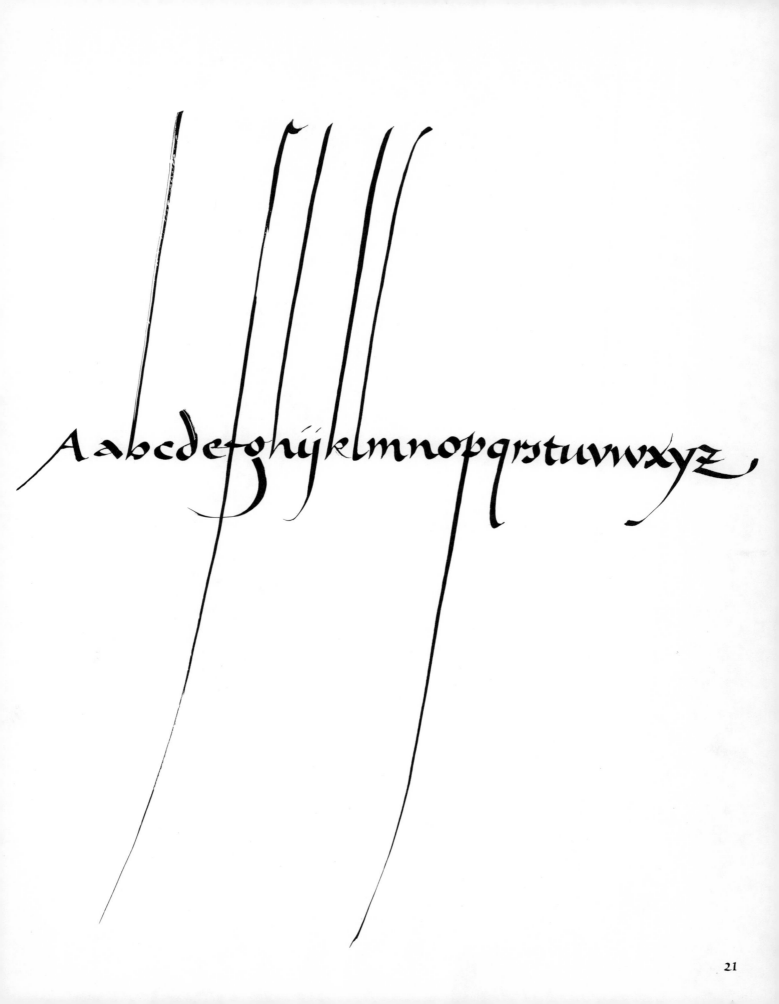

Aabcdefghijklmnopqrstuvwxyz

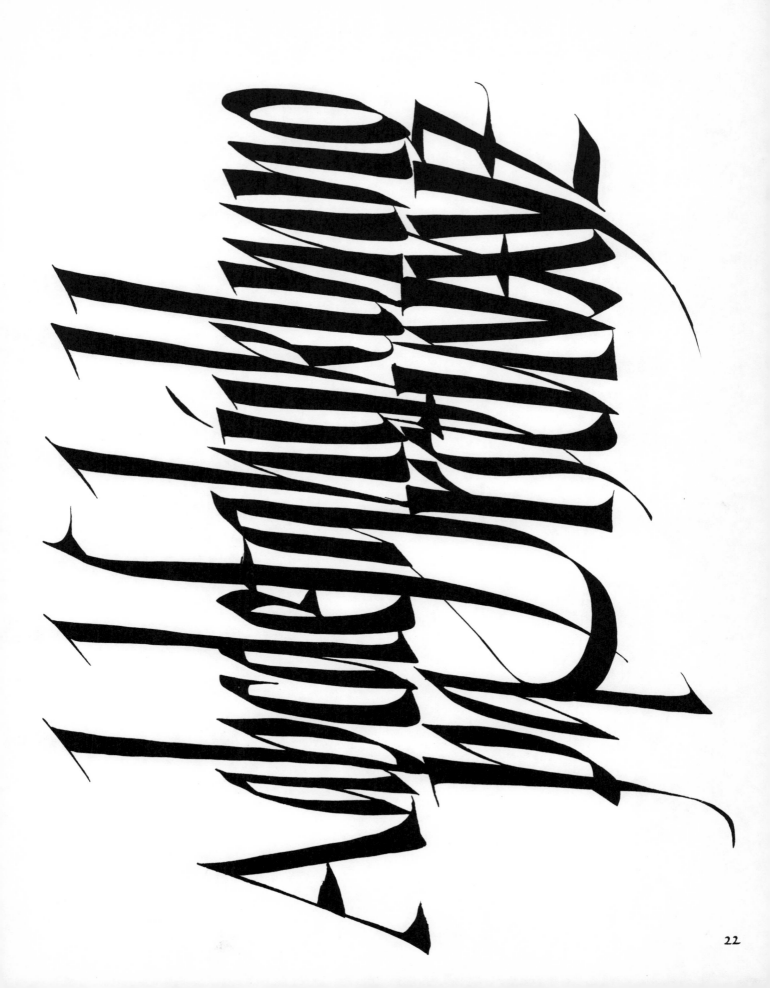

22

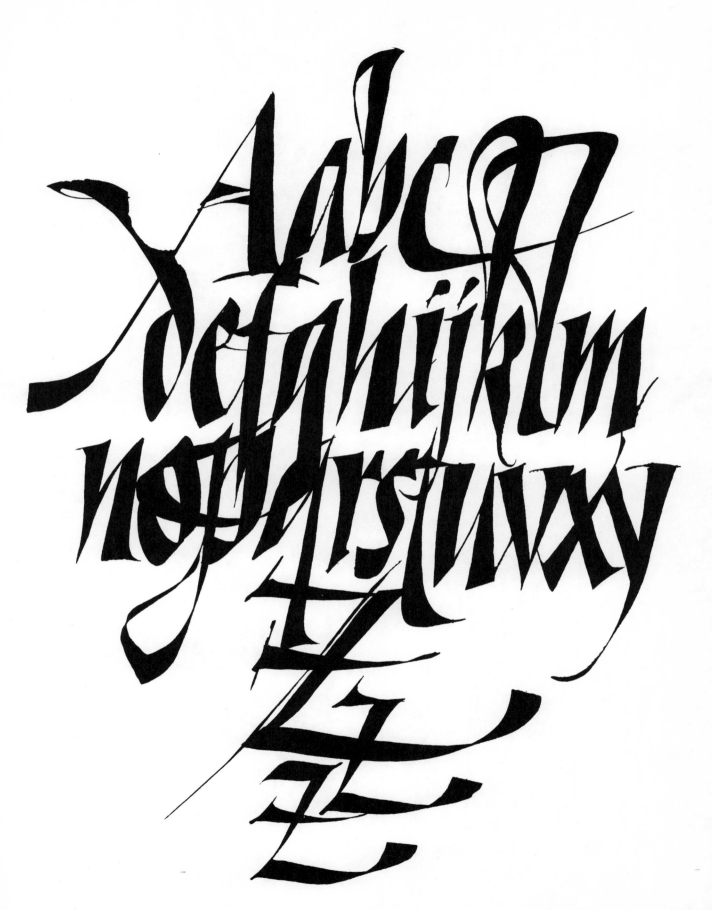

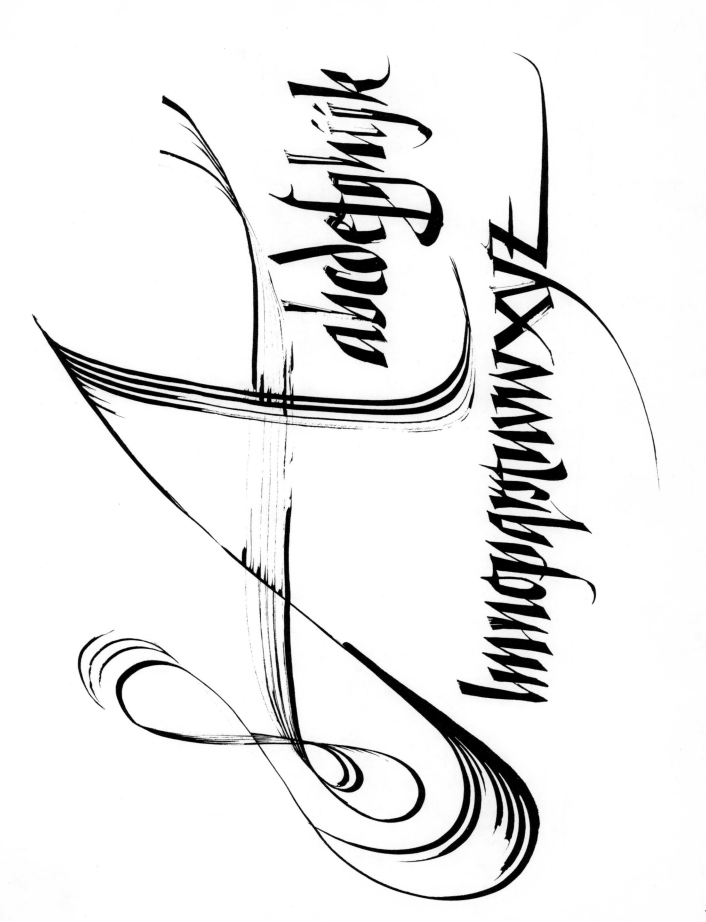

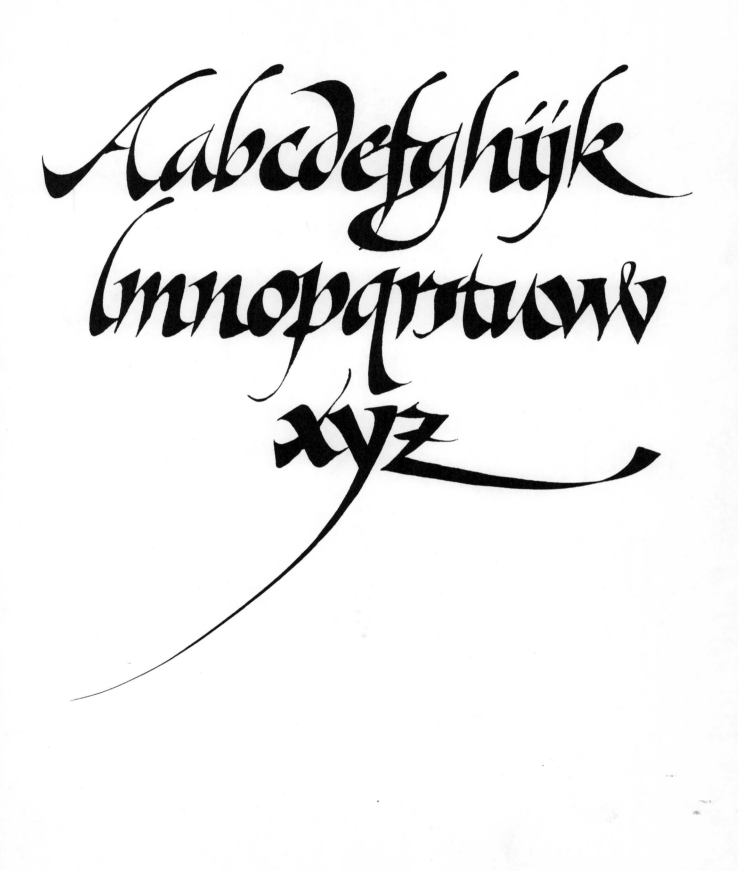

Aabcdefghijk
lmnopqrtuvw
xyz

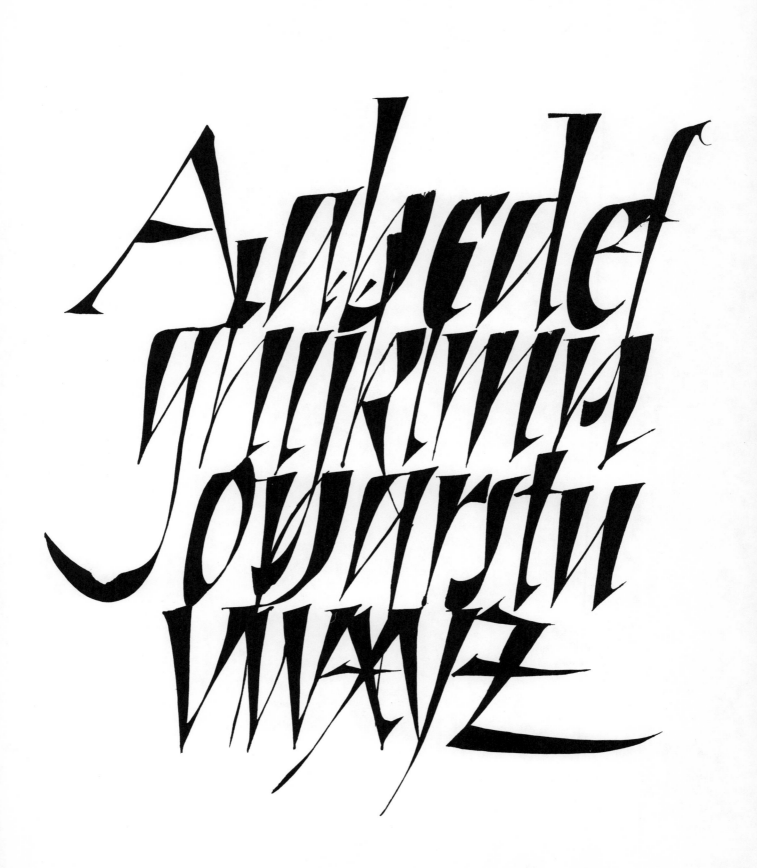

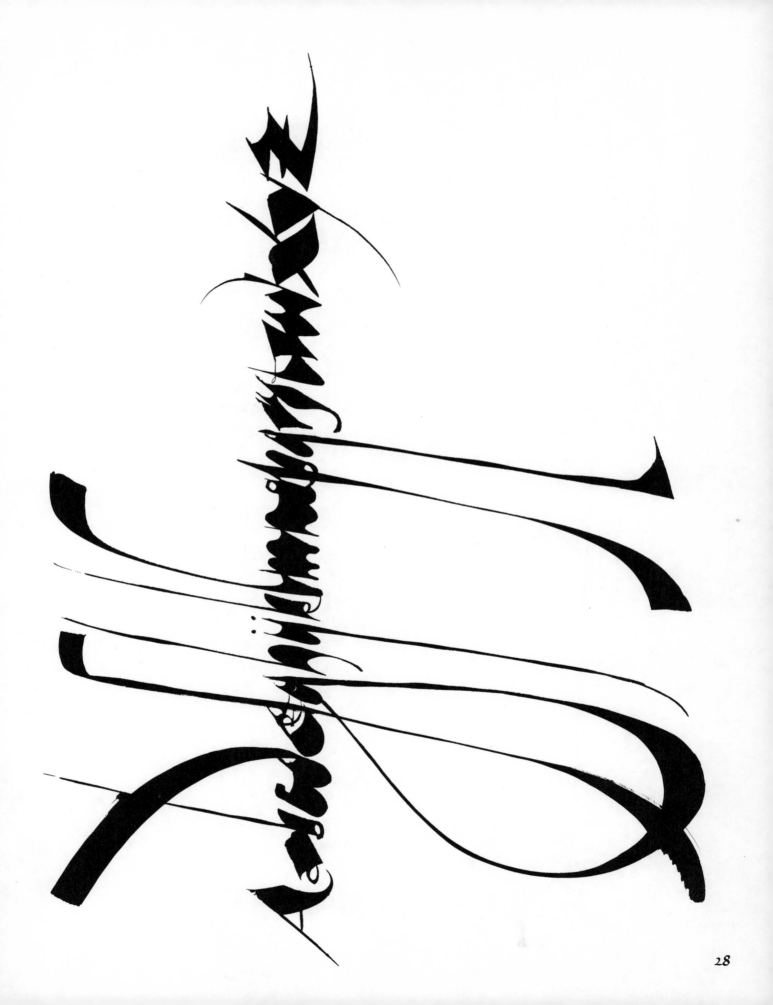

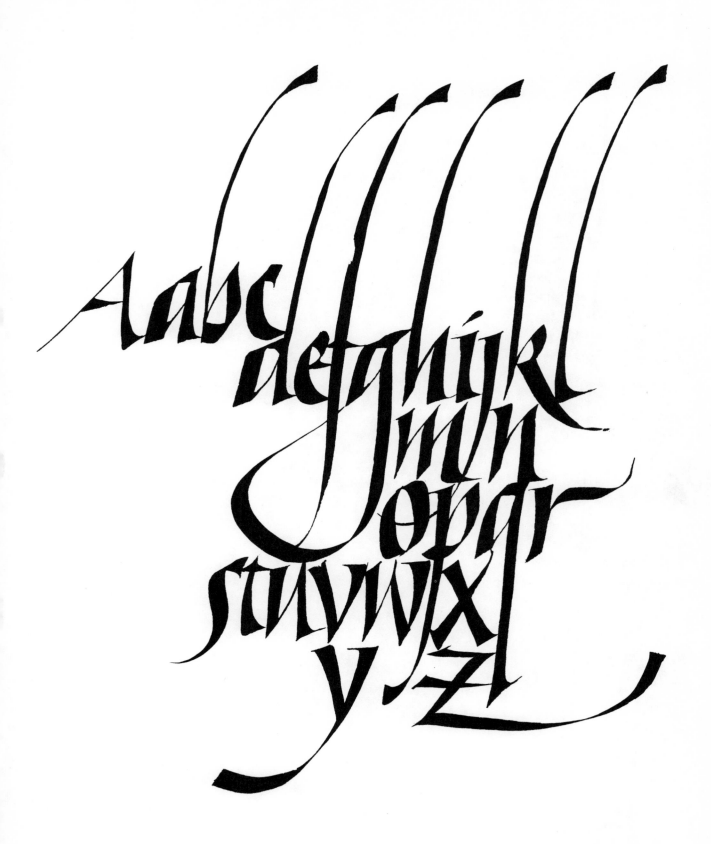

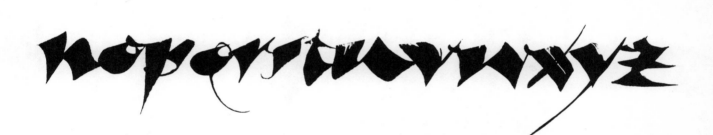

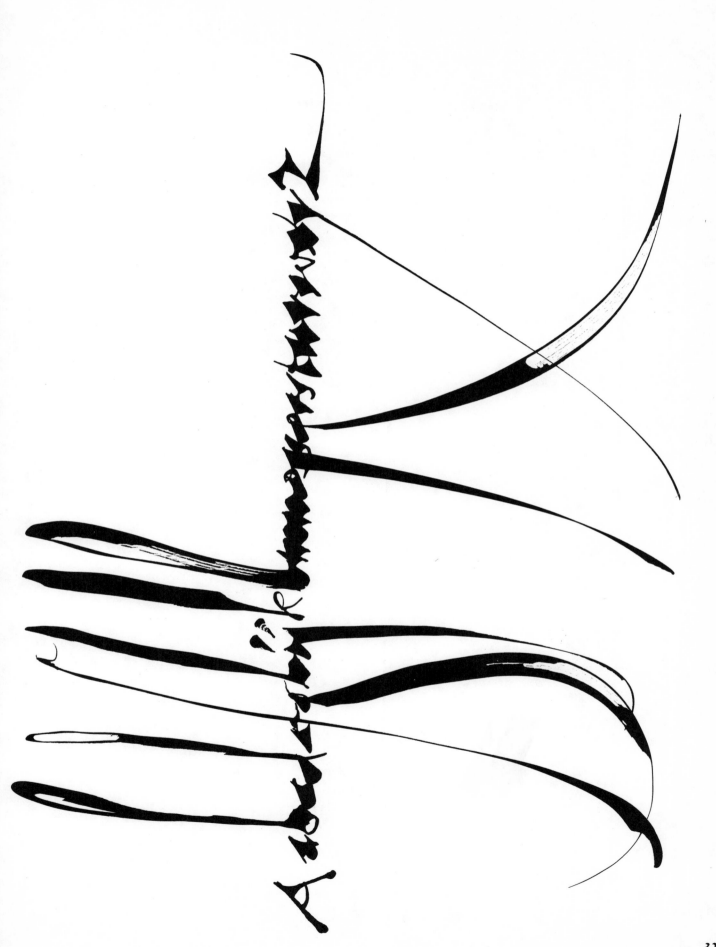

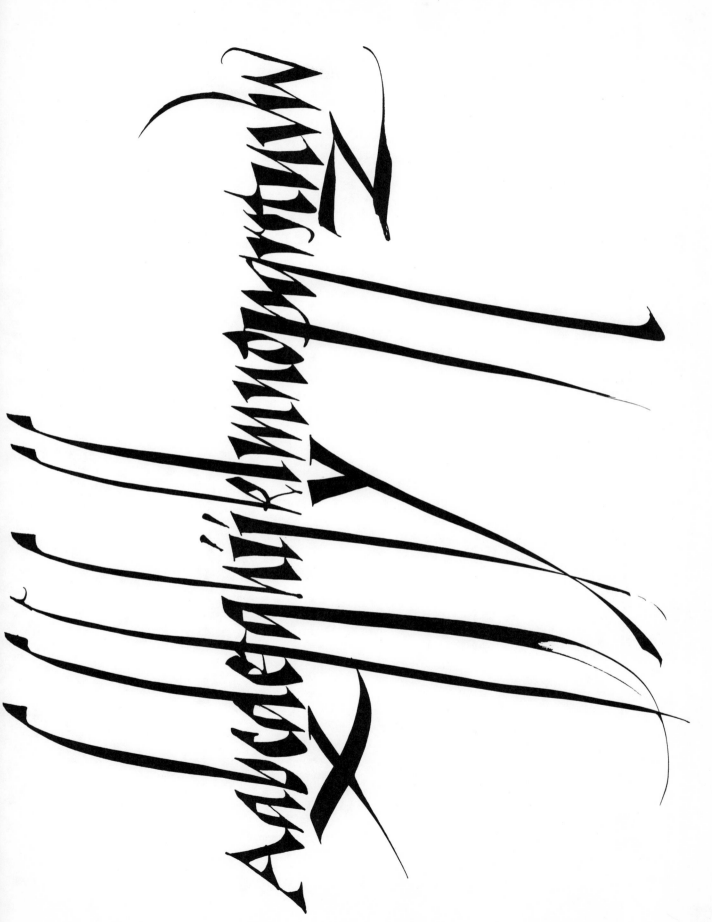

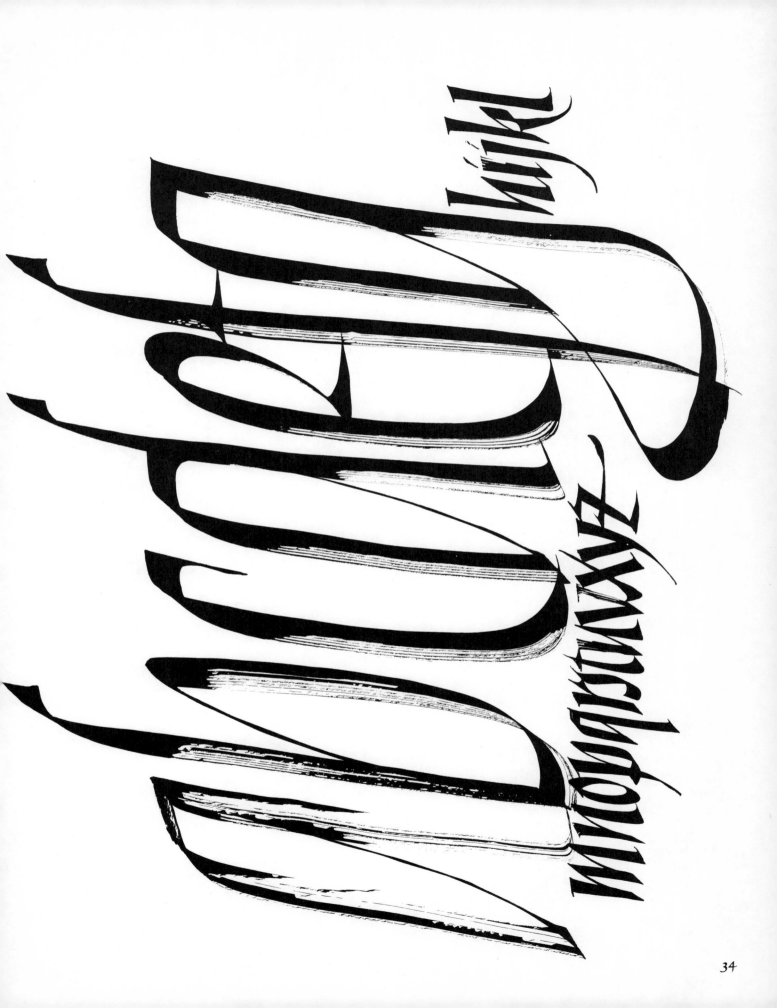

abcdefghijkl
mnopqrstuvwxyz

34

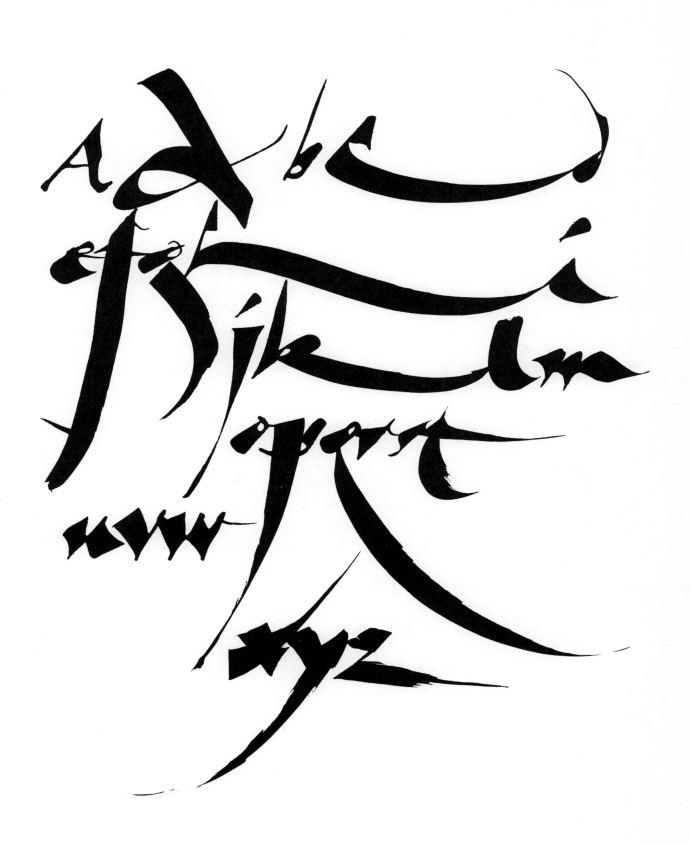

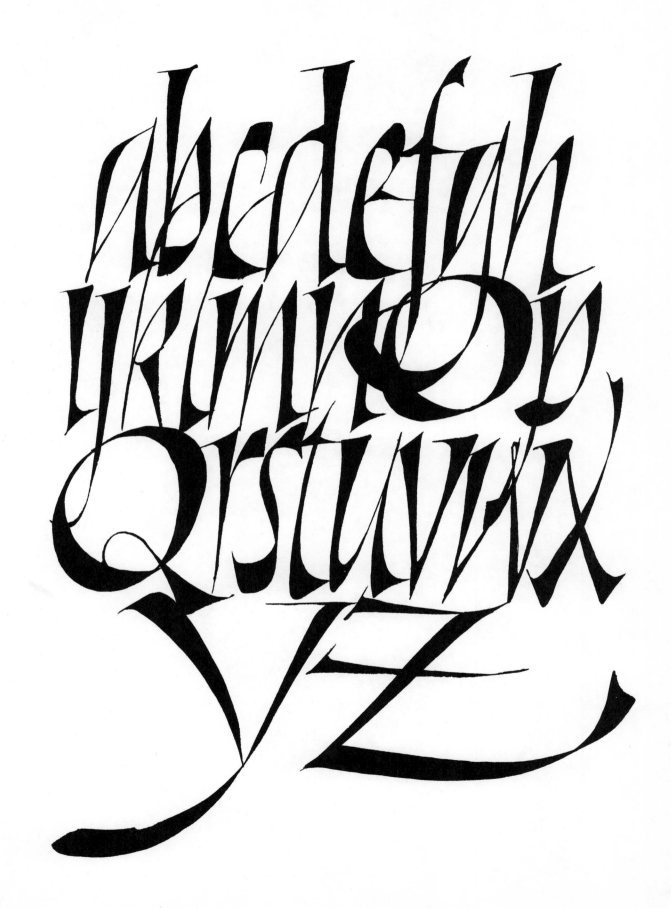

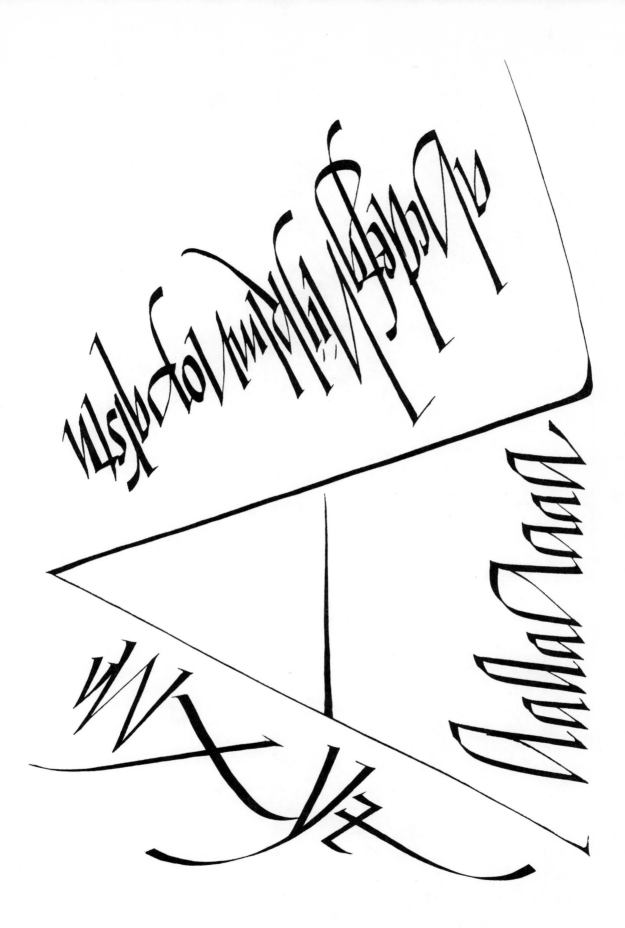

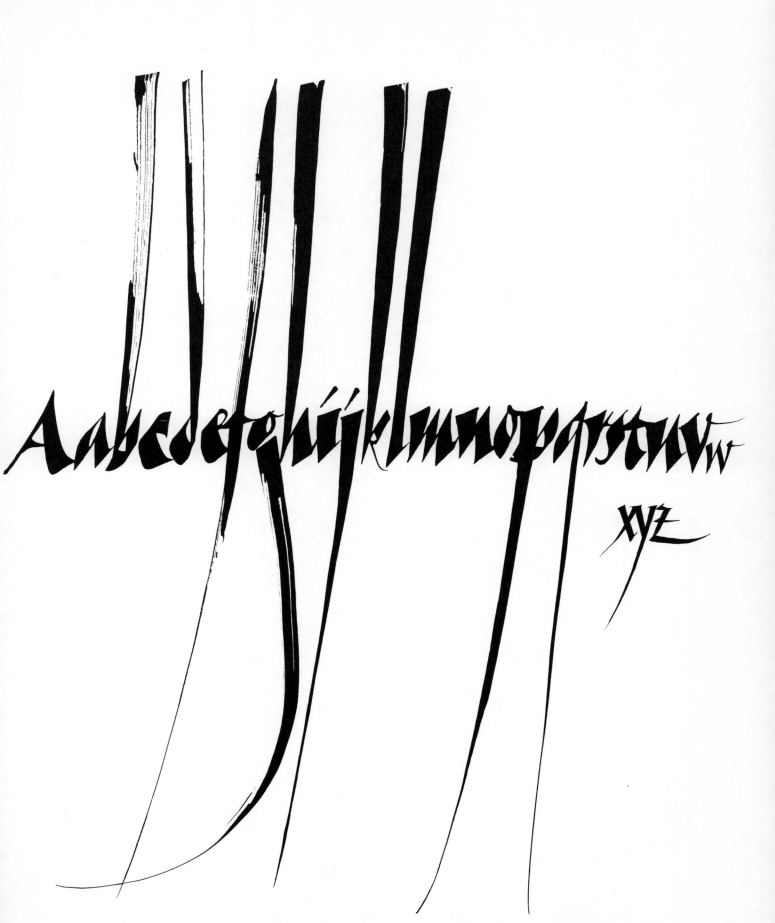

Aabcdefghiijklmnopqrstuvw
xyz

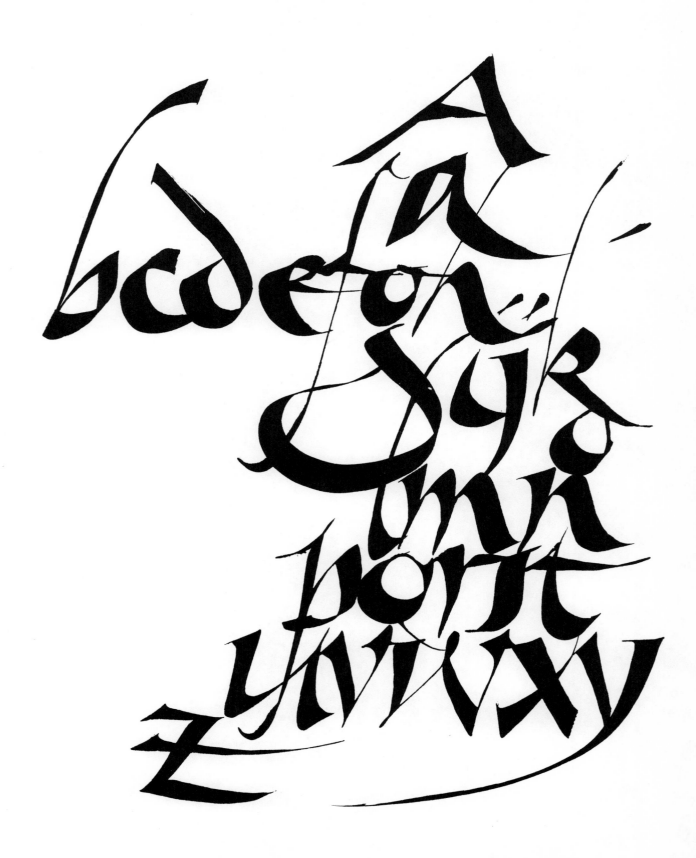

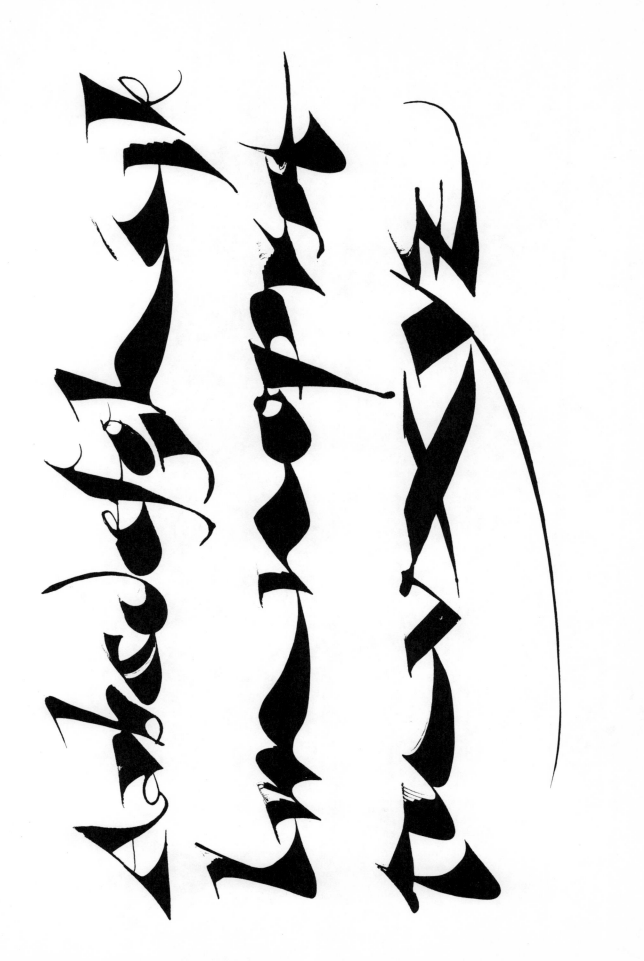

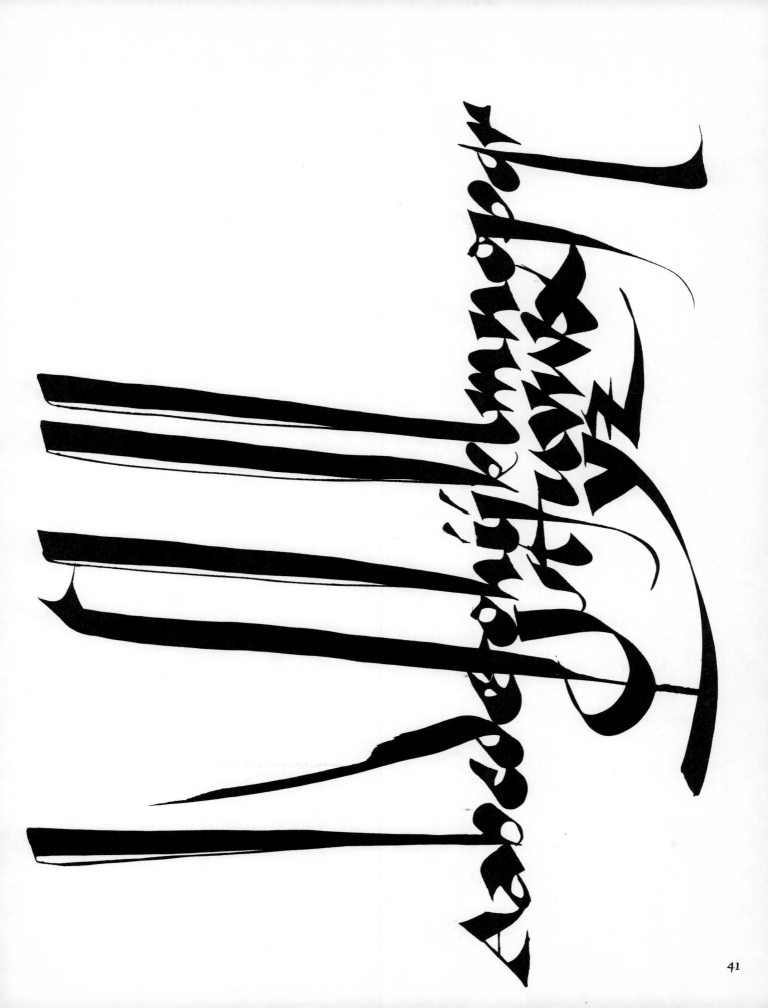

41

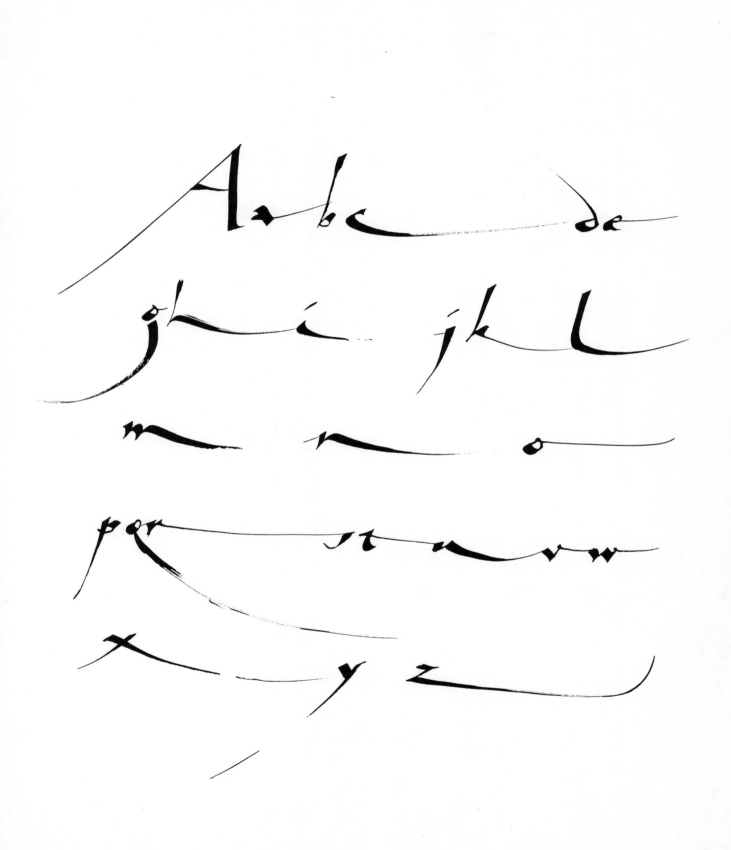

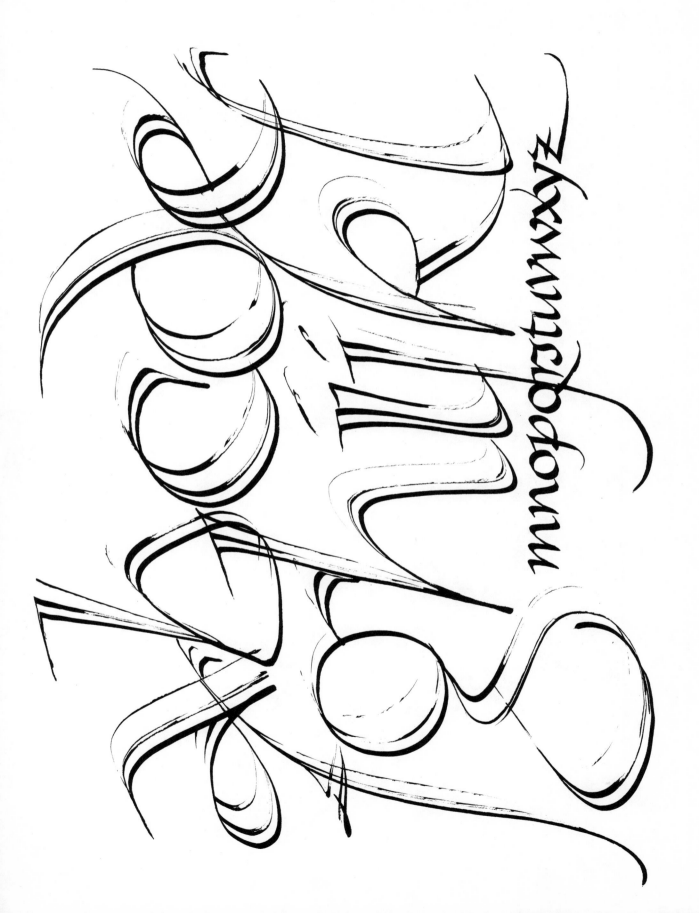

abcdefghijklmnopqrstuvwxyz

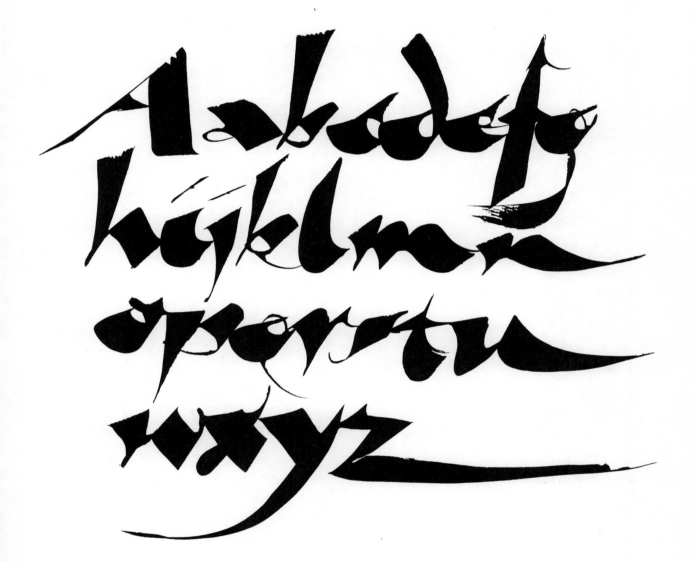

44

Aabcdefg
hijklmno
pqrstuvw
xyz

45

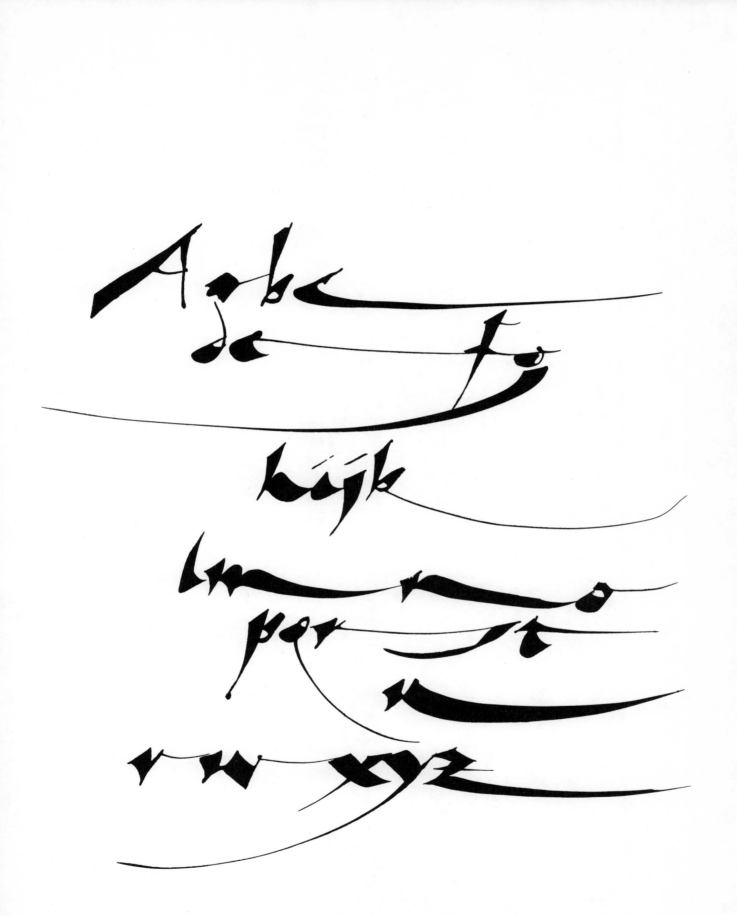

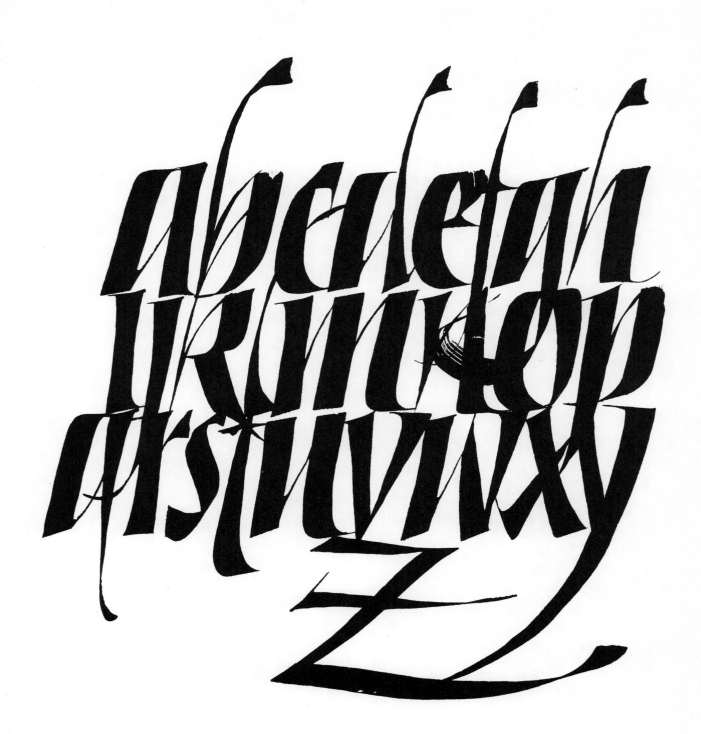

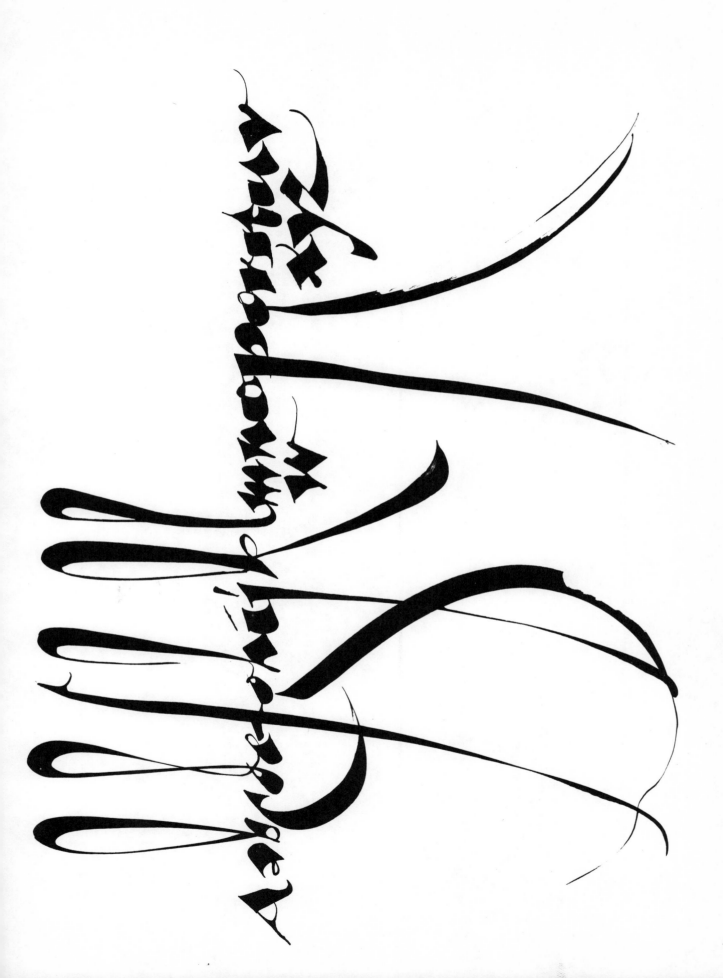

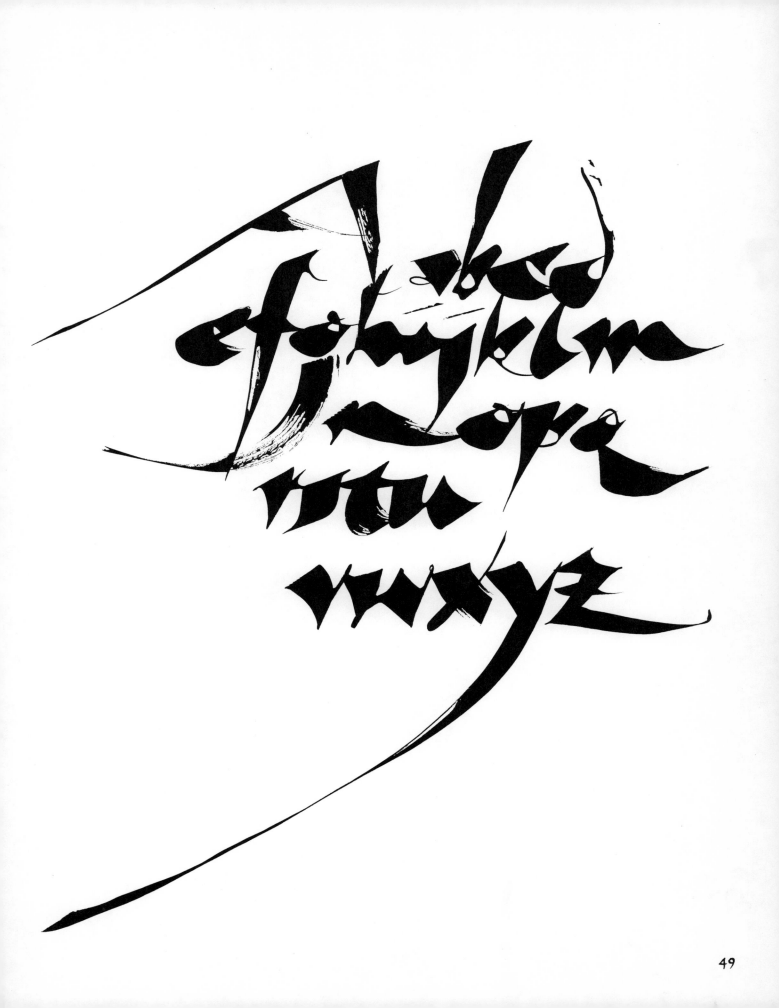

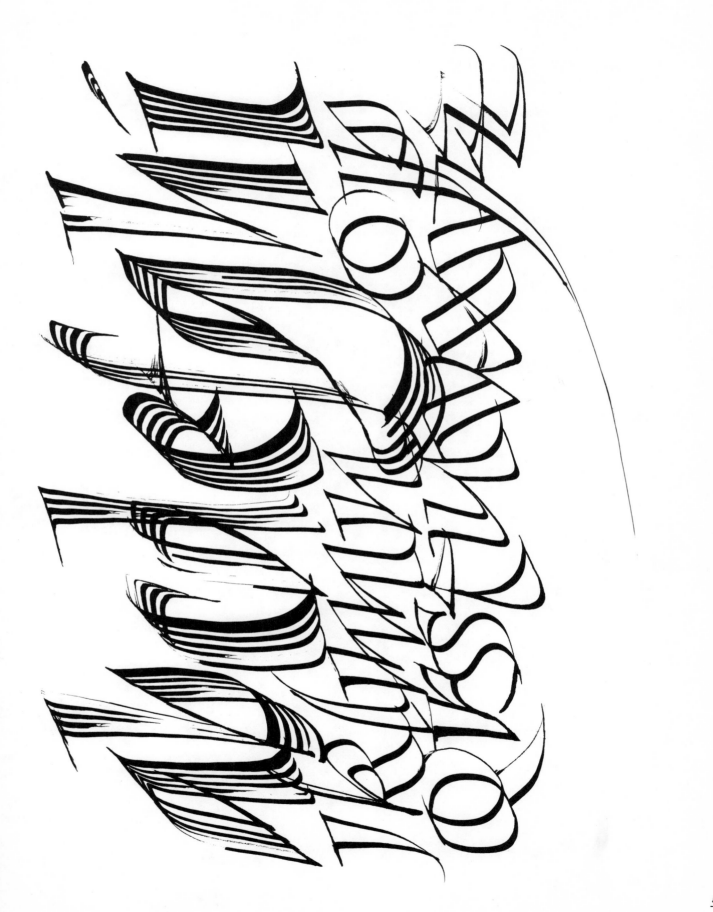

50

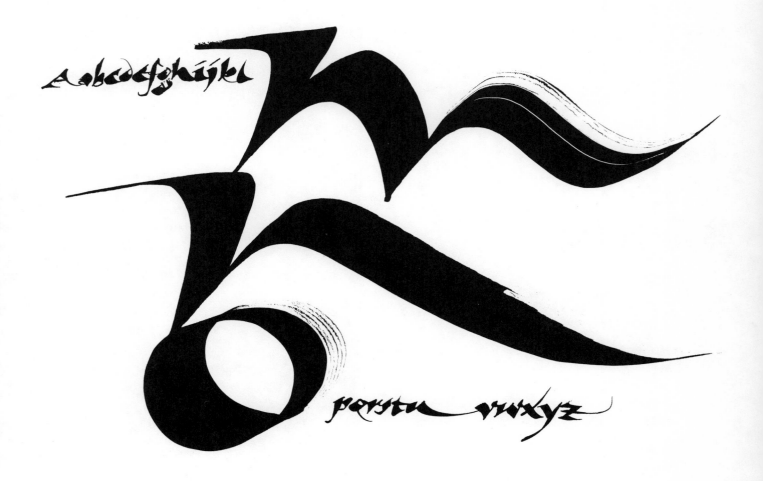

Aabcdefghijkl

pqrstu vwxyz

51

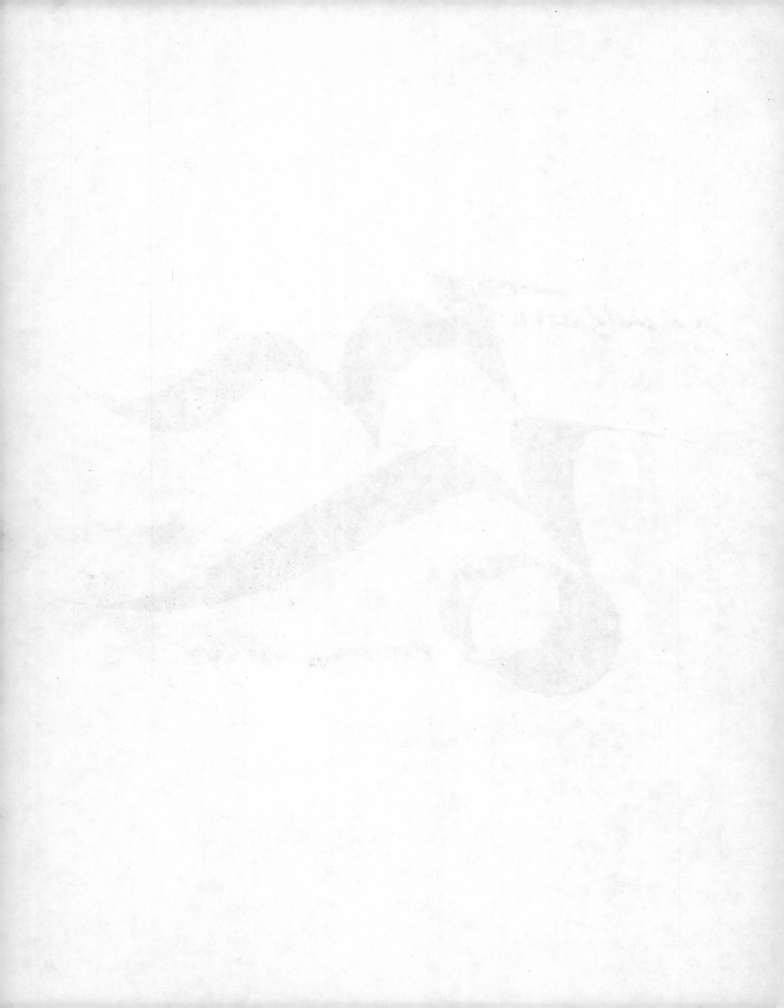

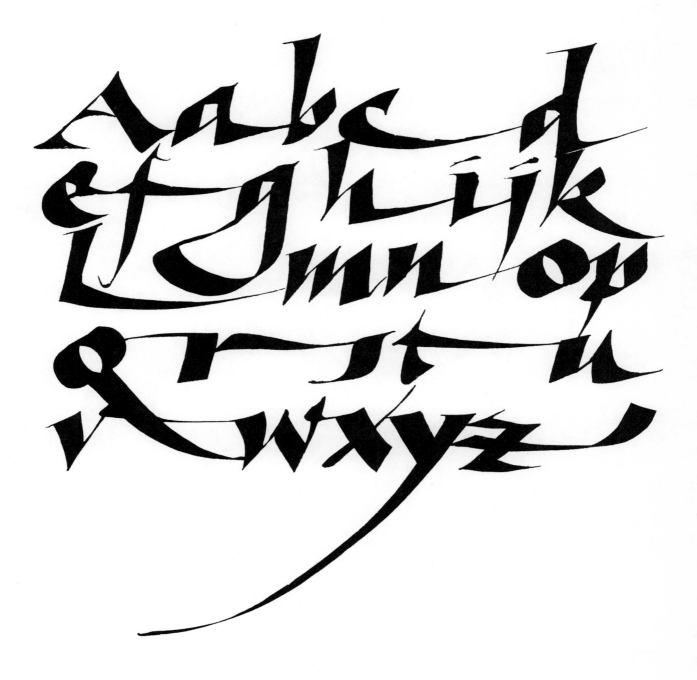

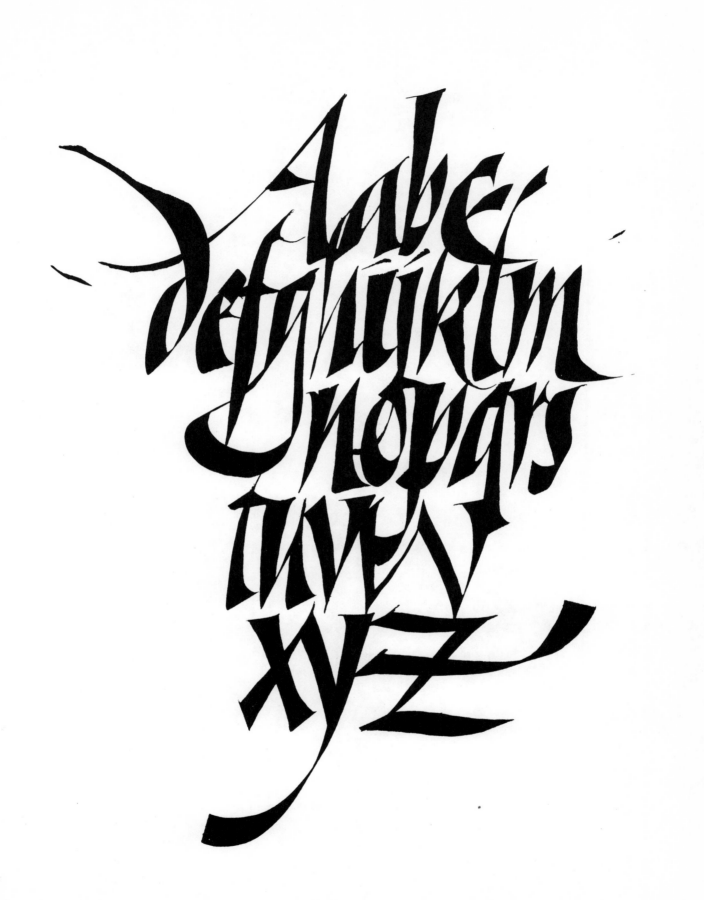

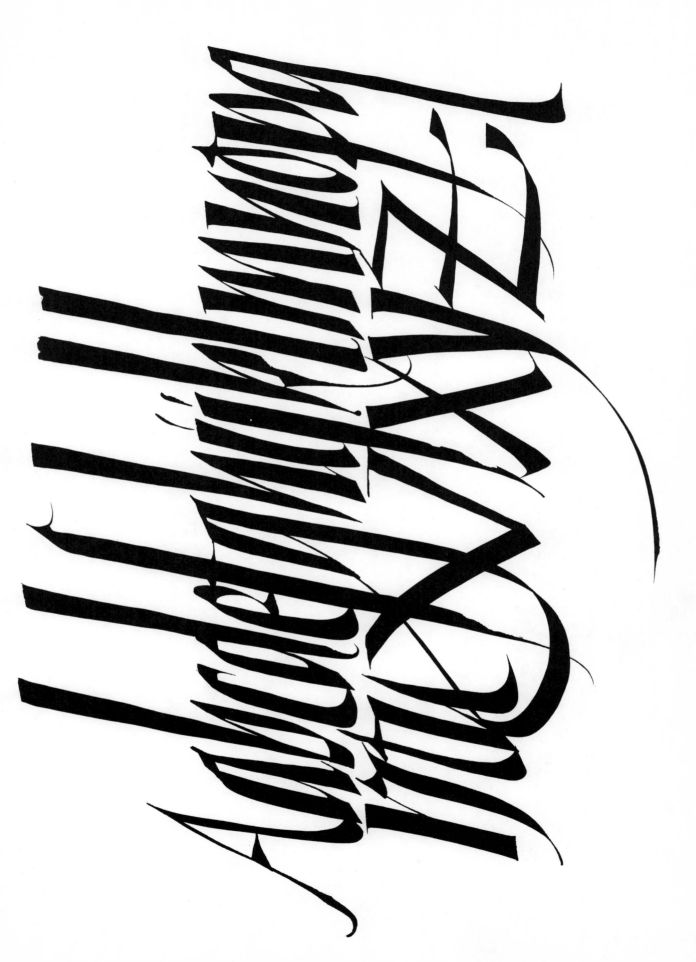

55

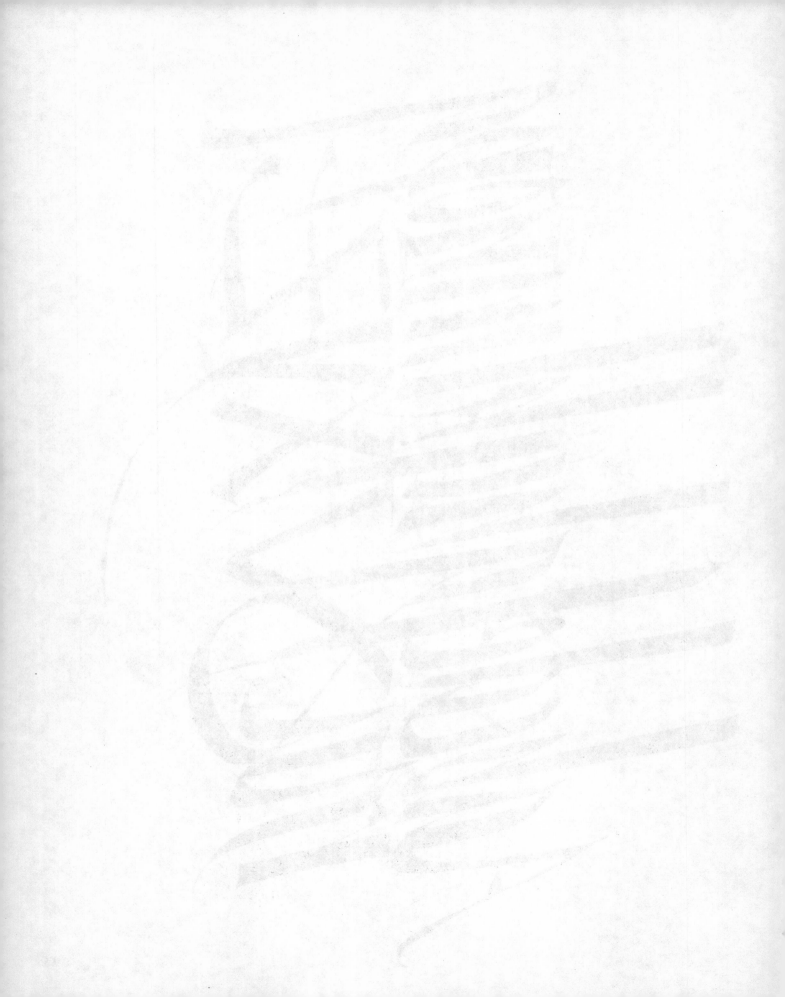

Aabcdefghijklm

nopqrstuvwxyz

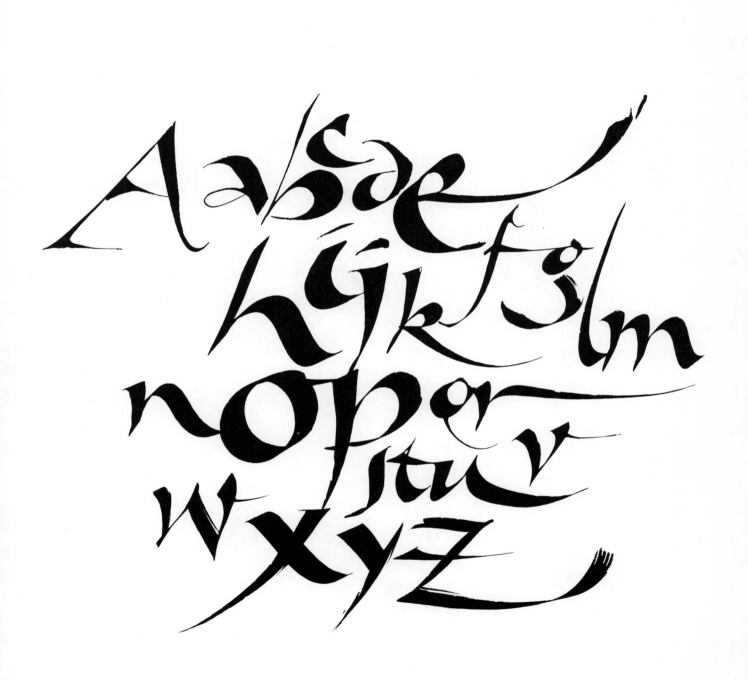

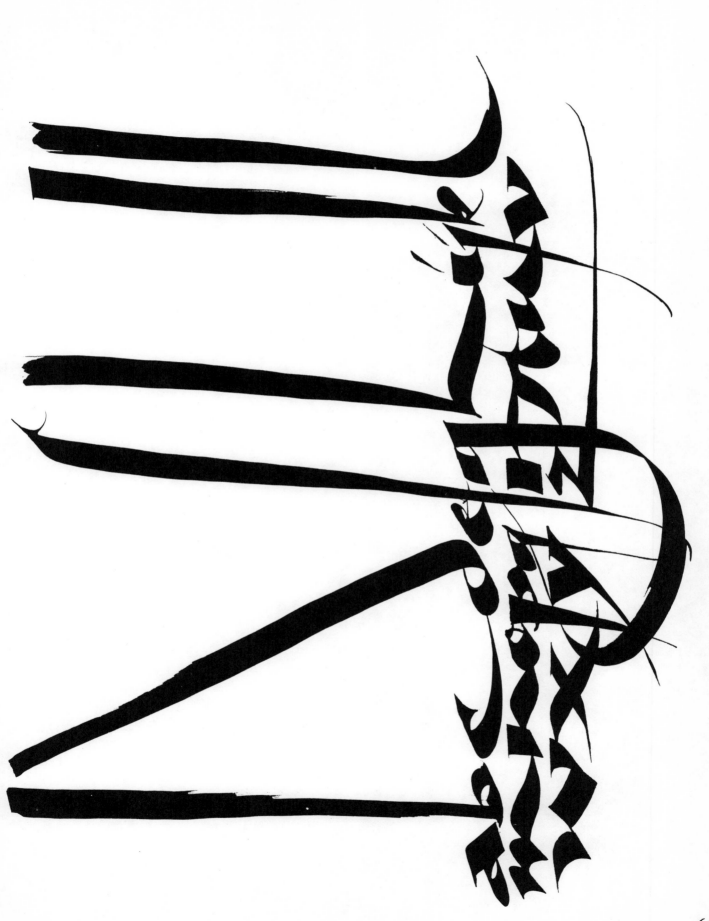

60

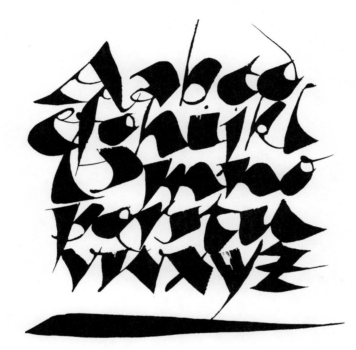